DOUGLAS I. BUSCH ITALIAN GARDENS

Douglas I. Busch

ITALIAN GARDENS

VORWORT Maria Carla Borghese
TEXTE Donald Doe, Thomas Schirmböck, Gabriele Uerscheln

EDITION BRAUS

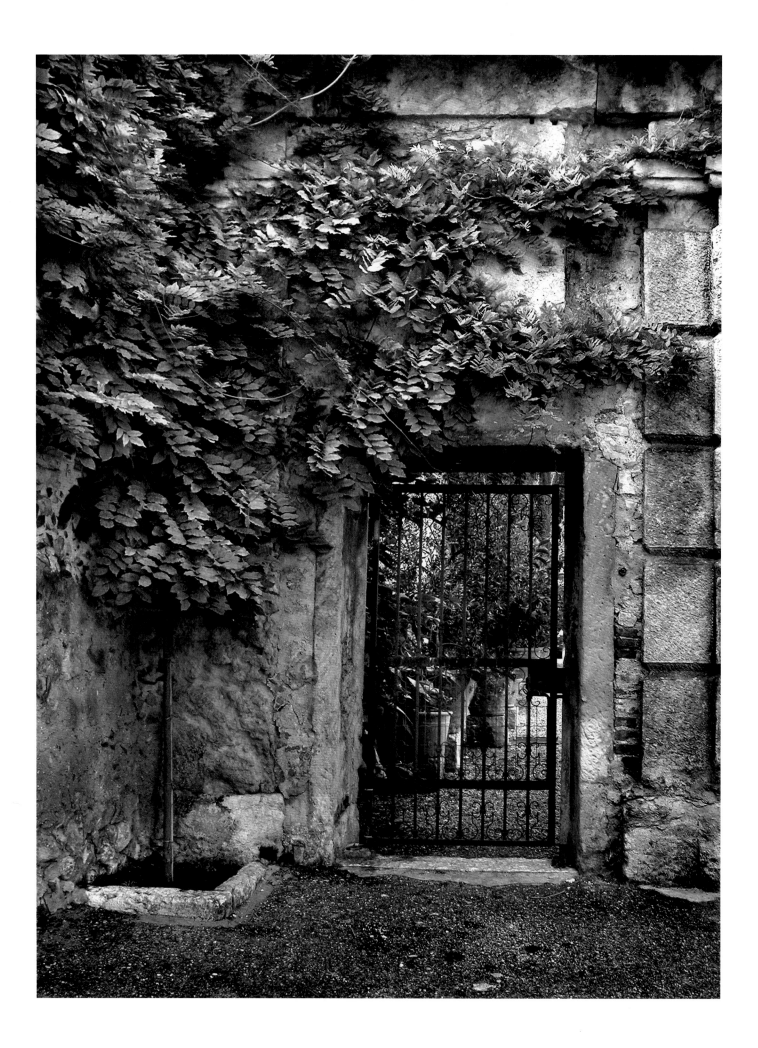

Ende Mai 2003 hatte ich das große Vergnügen, Douglas Isaac Busch und seine Frau in meinem Garten in den Case del Biviere in Sizilien zu treffen. Zur Erinnerung an diese Begegnung schenkte er mir das wunderschöne Buch *In Plain Sight*, mit außergewöhnlichen Schwarz-Weiß-Fotografien, wo Licht und Schatten in spannender Folge wechseln, mit solcher Eindringlichkeit und Ausdruckskraft, dass die Bilder wie Kupferstiche wirken und mich an die berühmten Radierungen Piranesis erinnern.

Das Fehlen der Farbe erweist sich bei diesen Fotografien als großer Vorzug, sie wirken dadurch wie Bilder der Erinnerung, die häufig keine Farbe brauchen.

Nun liegt dieser neue, kostbare Fotoband mit Aufnahmen mehrerer italienischer Gärten vor mir, in denen sich, manchmal fast schüchtern, die Farbe hervorwagt.

Nie wirkt sie dabei aufdringlich, dominant oder grell. Immer vermischt sie sich mit den grünen Schattierungen der Blätter, dem Grau der Steine, den Umrissen der Baumstämme.

Der Kraft von Schwarz und Weiß gelingt es, den Bildern der Gärten die Magie des Lichts, der Helldunkel-Effekte zu verleihen und so wahre Meisterwerke der Fotografie zu schaffen.

Man gewinnt den Eindruck, es nicht mit der exakten Wiedergabe des fotografierten Gegenstandes zu tun zu haben, sondern mit Imaginationen des Fotografen, für den diese Bilder aus dem Schwarz-Weiß hervorgegangen sind und dann nur ganz allmählich und nur in einzelnen Teilen von der Farbe durchdrungen wurden.

So schafft dieser Band eine neue, faszinierende Erfahrung, die es ermöglicht, in unseren Gärten bislang ganz unbekannte Aspekte zu entdecken.

At the end of May 2003, I had the great pleasure of meeting Douglas Isaac Busch and his wife in my garden in the Case del Biviere on Sicily. As a souvenir of this encounter, he gave me a copy of the delightful book, *In Plain Sight*, containing exceptional black-and-white photographs, in which light and shade give rise to an intriguing visual counterpoint of such force and expressiveness that the images have the quality of engravings and call to mind the famous etchings produced by Piranesi.

In these photographs, the absence of colour actually turns out to be a great advantage, as this gives them the effect of images conjured up by memory, the sort that often do not require any colour at all.

Now, I have in front of me this exquisite new book of photographs containing pictures taken in a number of Italian gardens, in which the colours reveal themselves diffidently, even shyly.

There is never a danger of them pushing themselves into the foreground or becoming over-dominant or shrill. They always blend into the green shades of the leaves, the grey of the stones and the contours of the tree-trunks.

The power of black and white infuses these pictures of gardens with the magic of light, the play of bright and dark, thus giving rise to genuine masterpieces of photography. One has the impression that what one is looking at is not merely an exact reproduction of photographed objects but rather has more to do with the imagination of the photographer, for whom the point of departure for these images was black and white, with the emergence of colour being a very gradual and subtle process confined only to certain sections.

Thus, this volume provides us with a new and fascinating visual experience that opens up the possibility of discovering aspects of our gardens of which we were previously unaware.

Maria Carla Borghese

Entrance to Back Courtyard Villa Arvedi

Träume immer anders immer verschieden
endlose Reisen endlose Reiche
immer seltsam immer wunderbar.
Joseph Cornells Theater der Gedanken:
Ausgewählte Tagebücher, Briefe und Mappen

Douglas Busch verbrachte das Frühjahr 2003 in Italien, wo er elf Gärten – zehn davon in Privatbesitz – fotografierte. Die Bilder rufen Reiseerinnerungen wach, über die man ins Träumen geraten kann. Durch Gärten auf einer Insel mit Blick auf die italienischen Alpen zu flanieren, und weiter zu Villen in der Ebene von Venetien, von dort zu dreien in der Toskana, eine davon mitten in Florenz, der Stadt der Renaissance. Nach Gartenspaziergängen in der Umgebung von Rom geht die Reise weiter in Richtung Süden, auf eine andere Insel, Ischia, die, größer als Capri, gleichfalls mit der Fähre von Neapel erreicht werden kann. Zu guter Letzt dann noch weiter südlich an die Ostküste Siziliens, in die Nähe von Syrakus.

Ein Jahrhundert, bevor Kolumbus nach Indien aufbrach wurde hier die Familie, die den Garten wiederhergestellt hat, Grundbesitzer.

Diese Reise fand im Schatten von Steineichen und Zypressenreihen statt. Die Gärten sind geordnete Welten aus Blattwerk und Strukturen, Sonnenlicht und kühlen Zufluchtsorten, Terrassen und gepflegten Hecken. Blumen gibt es wenige, Zurückhaltung durchzieht nicht nur den italienischen Garten (zum Teil auch den in die italienische Landschaft transponierten englischen Garten), sondern ebenso die Fotografien. Auf Isola Bella fängt Busch einen Blick auf den Lago Maggiore bei Sonnenuntergang ein, doch der Himmel ist nicht violett oder mandarinenfarben getüncht. Um die Farbe zu dämpfen ist das Bild digital verändert, wirkt beinahe schwarz-weiß. Dunkle, schlanke Baumstämme rahmen den Blick auf niedrige Büsche und Topfpflanzen – vielleicht kleine Zitronenbäume –, die auf einem Mäuerchen stehen. Fast silbern schimmert in der Ferne das Wasser. Das Bild strahlt in seinem Rhythmus der Symmetrien Ruhe aus.

Ein ähnlich radikales Beispiel für die Umsetzung visueller Erfahrung gibt es aus La Mortella. In diesem eher zeitgenössischen Garten richtet Busch, inmitten einer außergewöhnlichen und üppigen Anordnung von Blattwerk, sein Augenmerk auf eine smaragdfarbene Orchidee, die vor einem einzelnen fächerförmigen Blatt hängt. Das Bild ist als Studie von Strukturen und Grüntönen einfach und elegant wie ein japanisches Blumenarrangement komponiert.

In La Gamberaia entdeckte Busch in einem einzelnen Baum vor einer gewaltigen verwitterten Mauer ein verwandtes Motiv. Die Mauer selbst ist durchzogen von Schlieren, dunkelgrau auf weiß, ein organischer Rhythmus, dem Alter und der Witterung geschuldet. Sie macht die Zeit und die Mühe kenntlich, welche die Strukturierung und Ordnung der Natur der ansässigen Familie abverlangt; und dies seit Generationen.

Zwei grüne Türen, aufgenommen bei der Villa Reale, ist wie ein Diptychon in einem Bild aufgebaut. Ein schmuckloses, einfaches Regenfallrohr teilt das Bild. Auf jeder Seite ist eine bogenförmige Türöffnung mit einer alten hölzernen Tür zu sehen. Beide sind geöffnet, die dahinter liegenden Räume voller Gerümpel, einer Tür fehlt das Fensterglas, die andere hängt schief in den Angeln. Verankert sind sie in alterndem Mauerwerk; auf der linken Seite löst sich gelbbrauner Putz von den Ziegeln, auf der rechten Seite ist er grau und verwittert. Und doch ist dies nicht das trostlose Bild einer Ruine, sondern die subtile Balance aus verblassten Farben und sinnträchtigen Strukturen.

Weit im Süden, in Il Biviere, fängt Busch ein Bild ein, das dieses Thema fortsetzt. Lakonisch, jedoch fast irreführend benennt er es *Katzen im Fenster mit Sukkulente*. Die Katzen wirken winzig, das Fenster riesengroß, gerahmt wird es von streng geometrischen Quadern aus nahtlos gefügtem, grauem Stein. Das hohe Rechteck des Fensters ist exakt in zwei Hälften geteilt: Ein verblichen grüner Fensterladen ist geschlossen, der andere halb geöffnet und gibt nichts weiter preis als das Dunkel eines unbeleuchteten Innenraums. Dieses Spiel mit der Geometrie in Grau,

verblasstem Grün und dem Schwarz des Innenbereichs wird von einer gelbbraunen, beinahe roten Wand aus wettergegerbtem Mauerwerk gefasst, die von der sizilianischen Sonne gehärtet ist. Auch hier hat sich viel vom Putz abgelöst. Vor dieser groben, dem Anschein nach sehr alten Oberfläche wächst die überraschende und strahlend grüne Gestalt einer Sukkulente.

Diese Fotografie fängt die sinnlichen Kontraste Süditaliens ein: weiche Grüntöne und Ockergelb, dunkle Innenräume und helles Sonnenlicht, sanftes, im Wortsinne saftiges Leben und verwitterte, abgenutzte Oberflächen. Wir finden all dies inmitten einer Landschaft, die mit Ruinen gesprenkelt ist. Einige von diesen überwältigen uns mit dem Gefühl einer nahezu endlosen menschlichen Vergangenheit. Dieser Vorgeschmack auf die Bilder italienischer Gärten lässt bereits die wichtigsten Ingredienzien von Buschs Arbeiten anklingen: Sie sind rigoros komponiert, visuell komplex und beinahe immer elegant. Diese Eigenschaften haben das Schaffen des Künstlers – wenn auch bei der Entstehung von *Italian Gardens* ganz neue Techniken involviert waren – seit Jahrzehnten bestimmt. Denn Buschs frühe Arbeiten waren von der puristischen Ästhetik eines Ansel Adams, einer Imogen Cunningham, eines Edward Weston und anderer Mitglieder der Gruppe f/64 tiefgreifend beeinflusst. Er akzeptierte diesen Traditionsstrang, er stand und arbeitete an und in ihm. Seine Fotografien waren schwarz-weiß und ausnahmslos im schärfest möglichen Fokus und mit größtmöglicher Tiefenschärfe. Wie die übrigen Künstler der Gruppe f/64 benutzte auch er keinen Vergrößerer. All seine Arbeiten waren Kontaktabzüge, was bedeutet, dass die Negative direkt auf Fotopapier gelegt und dem Licht ausgesetzt werden. Grundprinzip und Vorteil solcher Abzüge ist, dass jedes auf dem Negativ eingefangene Detail durch absolut nichts störend beeinflusst wird. Nichts wird durch Vergrößerung unscharf. Und jedes sichtbare Faktum bleibt vorhanden. Ebenso wichtig ist, dass das Bild nicht beschnitten, das Negativ also vollständig abgezogen wird.

Dies macht die Auswahl der Begrenzung eines Bildes, ehe es wirklich geschossen wird, überaus anspruchsvoll. Bevor der Auslöser betätigt wird, muss man sich das Ganze tatsächlich bildlich vorgestellt haben.

Ein Wesensmerkmal Buschs komplexer Landschaftsstudien ist ihre formale Eleganz: Der Fotograf komponiert seine Vision der Realität, welche die Tradition eines perfekten Abzugs lieber ausweitet, anstatt sie zu analysieren. Einige Arbeiten, insbesondere die der atemberaubenden Berge und der Wüstenlandschaften des amerikanischen Westens, waren als eine Hommage an frühere, für ihn wichtige Künstler zu lesen. So hat er mit zwei von Edward Westons Söhnen zusammengearbeitet und stand mit Adams und Cunningham, beide ebenso Freunde wie Berufskollegen, in Verbindung.

Besonders Buschs Aufnahmen seines heimatlichen und landschaftlich eher wenig reizvollen nördlichen Illinois, seine Stadtansichten mit den Baustellen von Chicago oder Atlanta sowie die Frachthöfe von Denver, Colorado, stecken voll ironischer Momente. So fängt die Bandbreite von hellstem Grau zu Tiefschwarz die sich bedrohlich abzeichnende Oberfläche des Half Dome im Yosemite Nationalpark nicht ein, wohl aber einen gewölbten, ganz konkreten vorstädtischen Wassertank. Die glatte, weiße Form vor einer satten, immergrünen Wand besteht nicht aus Granit, sondern ist nur ein Zylinder zur Aufbewahrung von Propangas. Die Formen, die sich wiederholend das Feld eines sorgfältig komponierten Vordergrundes organisieren, sind keine Felsbrocken, vielmehr die Pfeiler für den Chicagoer Lakeshore Drive, der sich gerade im Bau befand. Tatsächlich erweiterten Buschs Kameras – vom Fotografen selbst entworfen und hergestellt – mit ihren gewaltigen Ausmaßen die Tradition des perfekten Abzugs in der Fotografie des 20. Jahrhunderts. So sind die 8 x 10 Inch Kameras, die Adams und die Gruppe f/64 benützten,

vergleichsweise handlich und leicht zu transportieren. Hingegen reichen die Filmplatten, die in Buschs Kameras verwendet werden, von 8 x 20 bis hin zu kaum mehr zu beherrschenden 40 zu 60 Zoll – die Haltevorrichtung für den Film ist hier beinahe so groß wie die Platte eines gewöhnlichen Esstisches. Die außerordentliche Detailgenauigkeit in den riesengroßen Kontaktabzügen erweiterte die Logik der puristischen Ästhetik ins Extrem.

Dass Busch nun Digitalkameras und Scanner für sich eroberte, um seinen Spielraum als Fotograf weiter zu vergrößern, ist vielleicht nicht überraschend; erlauben sie ihm doch – zumindest im Kontrast zu seinen frühen Touren durch amerikanische Städte – ein beinahe unbeschwertes Reisen.

In mancher Hinsicht ist diese Veränderung aber doch dramatisch und ziemlich unerwartet. Bis zur Gegenwart seiner künstlerischen Entwicklung lebt Busch in Malibu, Kalifornien, wo er sein Studio hat; hier hat er sein architektonisches Szenario auf einer Bergkuppe entworfen mitsamt den bemerkenswerten zeitgenössischen Gebäuden. Internationale Anerkennung errang er als Schwarz-Weiß-Fotograf, als ein Meister des Abzugs und als Kamera-Designer. Seine Arbeiten finden sich weltweit in privaten Kunstsammlungen, in Kunstmuseen und in bedeutenden Sammlungen von Unternehmen, Colleges und Universitäten. In gewisser Weise ist Buschs Tour durch italienische Gärten eine Reise durch eine Kultur, wie seine früheren fotografischen Aufenthalte in Atlanta, Chicago und Denver. Allerdings fangen seine Stadtansichten die unsteten amerikanischen Rhythmen von Verfall und Erneuerung, Zerstörung und Aufbau ein. Das Projekt *Italian Gardens* dagegen stellt Natur dar, die durch Kultur verwandelt und vermittelt wurde. Die Gartentradition wurzelt in der Renaissance und transportiert selbst heute die Vision von menschlicher Kontrolle über eine wohltätige Natur: Die Orchestrierung von Sonnenlicht und Schatten, Träume einer immergrünen Ordnung. Und für

diese Ordnung hat Busch neue Orchestrierungen von Sonnenlicht und Schatten entwickelt. Er erweiterte seine fotografische Ausrüstung um den Computer und setzte ihn ein, um die Farbe vieler seiner Bilder zu dämpfen. Der Kontrast zwischen eigentlich Ähnlichem unterstreicht die Bedeutung dieser Entscheidung des Künstlers. Auf der Isola Madre fängt er die Strahlen des gleißenden Sonnenlichts ein, das durch die Blätter einer einzigen kleinen Palme fällt. Hinter der Palme ragt eine Wand aus dunkelgrünem Blattwerk empor, vor der Palme glänzt in hellen Tönen niedriges Immergrün. In La Mortella richtet er seine Kamera aufwärts, auf die verflochtenen Blätter von Palmen. Hier wurde die Farbe reduziert. Der Himmel ist silbergrau. Die Blätter haben nur noch einen Hauch von Grün. Das durchgängige Sujet ist Struktur und zartes Muster; als Ganzes ist es nahezu abstrakt.

Als Werk ist *Italian Gardens* nicht nur die zeitgenössische Vision einer Tradition, die durch die Jahrhunderte und die Einflüsse, die Italien formten, modifiziert wurde. Es gehört auch zur Tradition der Schriftsteller und Künstler, die Erinnerung zu erforschen. Hier und dort bleiben Details in völlig – oder beinahe völlig – gesättigter Farbe bestehen, aber über der ganzen Serie liegt Frieden. Annähernd monochrom offeriert Bild um Bild nicht die Farbschattierungen, sondern das Wesen der erinnerten Orte und ermöglicht einen gemächlichen Spaziergang durch die Zeit.

Donald Doe, Grinnell College

Douglas Busch spent the spring of 2003 in Italy photographing 11 gardens, 10 of them privately owned. The images evoke a trip to dream over: a stroll through gardens on an island with views of the Italian Alps, and on to villas on the plains of the Veneto and thence to three in Tuscany, one of those in the heart of Renaissance Florence. After garden walks in the environs of Rome, this trek moves south again, to another island, larger than Capri and also reached by ferry from Naples, and yet further south, to the east coast of Sicily, near Siracusa, where the family that has restored the garden became the land owners exactly a century before Columbus sailed for India and found himself in the Caribbean Sea. This is a tour made in the shade of ilex arbors and files of cypress; the gardens are orderly worlds of foliage and textures, sunlight and cool shelter, terraces and manicured hedges. Flowers are few.

Restraint suffuses not only the Italian Garden (even, to some extent, the English Garden transposed to the Italian landscape) but the photographs as well. At Isola Bella, Busch captured a view of Lake Maggiore at sunset, but there is no purple and tangerine sky. Digitally altered to mute the color, the image is nearly black and white. Dark and slender tree trunks frame the view of low shrubs and potted plants—perhaps small lemon trees—set out on a low wall. Water, nearly silver, gleams in the distance. The image is quiet, a rhythm of symmetries.

There is an equally radical instance of editing visual experience at La Mortella. In that more modern garden, amid an extraordinary and lush array of foliage, Busch focused on one emerald orchid hanging in front of a single fan-shaped leaf. This is a study in textures and greens, the image apparently as simple and elegantly composed as a Japanese flower arrangement. At La Gamberaia, Busch found a similar moment in a lone tree against a weathered and towering wall. The wall is streaked with mold, dark gray against white, an organic rhythm denoting age and weather, signifying time and the effort demanded by these projects of structuring and ordering nature that occupied the resident family for generations.

Two Doorways with Green Doors, taken at Villa Reale, is organized as a diptych. An unadorned and homely drainpipe divides the picture. To each side are arched doorways and old wooden doors. Both are open to rooms filled with debris, one door with the window glass long gone, the other sagging on its hinge. These are set into aging walls; on the left, tawny beige stucco is falling away from the underlying brick; to the right, the stucco is gray and weathered. But, perhaps curiously, this is not a dismal image of ruin but a subtle balance of faded color and evocative textures.

Busch captured an image that continues this theme at Il Biviere far to the south. Succinctly but almost misleadingly, he titled the picture *Cats in Window, Succulent*. The cats seem tiny; their window is very large and framed in severely geometric slabs of smoothly finished gray stone. The tall rectangle of the window is divided precisely in half: one faded green shutter is closed, one half-open, revealing nothing but the dark of an unlit interior. In gray, bleached green and the black of indoors, this play of geometry is surrounded by a tawny, almost red wall of weather-beaten masonry baking under the Sicilian sun. Here too, much of the stucco has fallen away. Against that rough, seemingly ancient surface grows the astounding and bright green shape of the succulent.

This photograph captures the sensuous contrasts of southern Italy: soft greens and ochre, interior dark and bright sunlight, soft, (literally) succulent life and weathered, time-worn surfaces—all of that in a landscape dotted with ruins, some of them vast, and suffused with a sense of a nearly endless human past.

This taste of Italian garden images hints at main ingredients in Busch's work: rigorously composed, visually

complex, and almost always elegant. Though creating the *Italian Garden* images have involved very new technologies, those qualities have defined the artist's work for decades.

His early work was profoundly influenced by the purist aesthetic of Ansel Adams, Imogen Cunningham, Edward Weston, and other members of Group f/64. Honoring this tradition, situated within it and contributing to it, Busch's photographs were black and white, and invariably in the sharpest possible focus; they included the greatest possible depth of field and were meticulously printed on glossy paper. Like the f/64 artists, he did not use an enlarger. All of his works were contact prints, that is, negatives placed directly in contact with the photographic paper and exposed to light. The rationale and advantage of such prints is that nothing whatsoever interferes with the detail captured on the negative. Nothing is blurred by magnification. Every visual fact is present. Further, and equally important, the image is not cropped at all; the entire negative is printed. This makes the process of framing an image before actually taking the picture very demanding; the whole must be visualized before the shutter is tripped.

The hallmark of Busch's extensive studies of landscape is a formal elegance that makes it clear the photographer was composing a vision of reality that extended—rather than deconstructed—the tradition of the Perfect Print. Some works, especially of the breathtaking mountain and desertscapes of the American west, were homage to the earlier artists so important to him. (Indeed, he has worked with two of Edward Weston's sons and associated with Adams and Cunningham as both friends and professional colleagues. His most recent effort came in 2000 when Busch produced a series paring photographs of German and French castles in Alsace and in the Palatinate with images of structures from the same era built by Native Americans.)

Other images, notably of Busch's native and non-scenic northern Illinois, as well as cityscapes which include construction sites in Chicago and Atlanta, and the freight yards of Denver, Colorado, are touched with a sense of irony. Thus, for example, the range of palest gray to deep black does not capture the looming surface of Yosemite's Half Dome, but a domed and concrete suburban water tank. The sleek white shape against a lush wall of evergreens is not granite but a cylinder storing propane; the repeated, scattered shapes organizing the field of a carefully composed foreground are not boulders but the pylons for Chicago's Lakeshore Drive, under construction when Busch set up his camera.

In fact, the cameras Busch used capturing those images quite literally expanded this 20th century Perfect Print tradition in photography. They are immense, designed and built by the photographer. By comparison, the 8 x 10 view cameras employed by Adams and Group f/64 are handy and easily portable. Sheets of film used in Busch's cameras ranged from 8 x 20 to an almost unmanageable 40 by 60 inches—the film holder about as large as the top of an average dining table. The exquisite precision of detail in the vast contact prints extended the logic of the purist aesthetic about as far as possible. To further extend his range as a photographer, perhaps it is not surprising that Busch would seize upon digital cameras and computer scanners—while allowing him to travel, at least by contrast with his earlier tours of American cities, almost unencumbered.

But in some respects, this change is dramatic and quite unexpected. Busch, by this hour in his career, lives and has his studio in Malibu, California, where he designed the entire hilltop setting and the remarkable contemporary buildings sited on it. He has won international respect as a photographer in black and white, as a master printer and as a camera designer. His work is found internationally in private art collections, in museums of art, and in distinguished

collections held by corporations, colleges and universities. In a sense, it could be argued that Busch's tour of Italian gardens, like his earlier photographic sojourns through Atlanta, Chicago, and Denver, is a journey through a culture. But his city views capture the erratic American rhythms of decay and renewal, destruction and construction. *Italian Gardens* depict nature transformed and mediated by culture. The garden tradition is rooted in the Renaissance and conveys even now a vision of human control over nature that is beneficent, orchestrations of sunlight and shade that are dreams of evergreen order. And to that order, Busch has generated new orchestrations of sunlight and shade. Adding a computer to his photographic equipment, Busch mutes the color of many of his images. The contrast between rather similar ones underscores the impact of the artist's decision. At Isola Madre, he captured rays of bright sunlight shining through the leaves of a single small palm. Behind the palm is a wall of dark green foliage, in front of the palm glistens the bright color of a low evergreen. At La Mortella, he aimed his camera slightly upward, at the interlaced leaves of palm trees. Here, color has been subtracted. The sky is a silver gray. The leaves only hint of green. The enduring subject is texture and delicate pattern; the whole is very nearly abstract.

As a body of work, *Italian Gardens* is not only a contemporary vision of a tradition that has been transformed by centuries and altered by the influences that have shaped Italy. It belongs to the tradition of writers and artists exploring memory. Here and there, details persist in fully—or nearly fully—saturated color, but quietude suffuses the entire series. Approaching monochrome, image after image offers not the hues but the essence of remembered places, offering a slow walk through time.

Donald Doe, Grinnell College

12 Tree Silhouette at Sunset Isola Madre

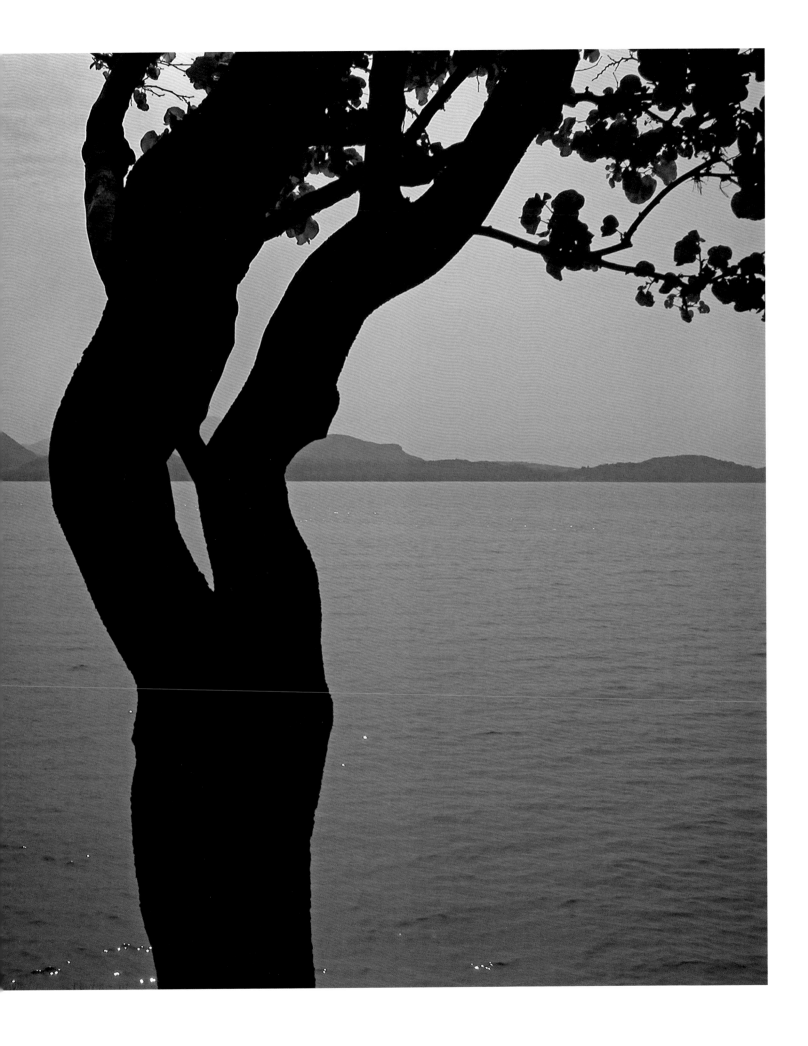

14 Tree Trunk with Grasses Isola Bella

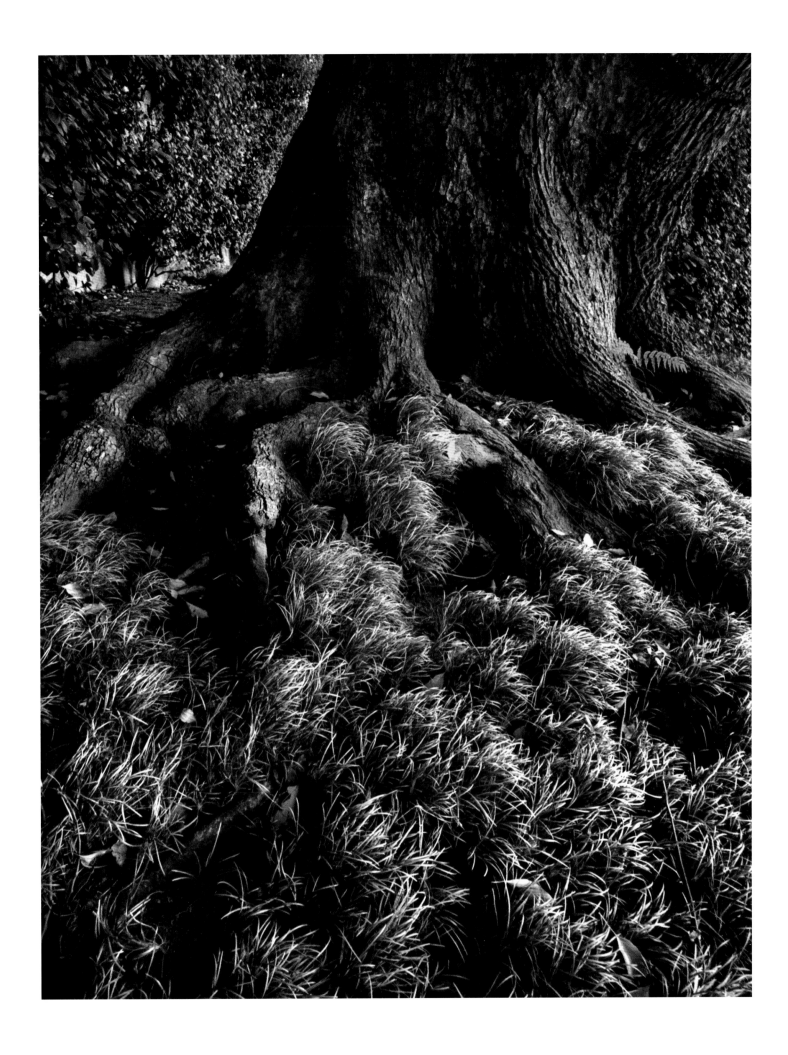

16 View from upper Terrace La Mortella

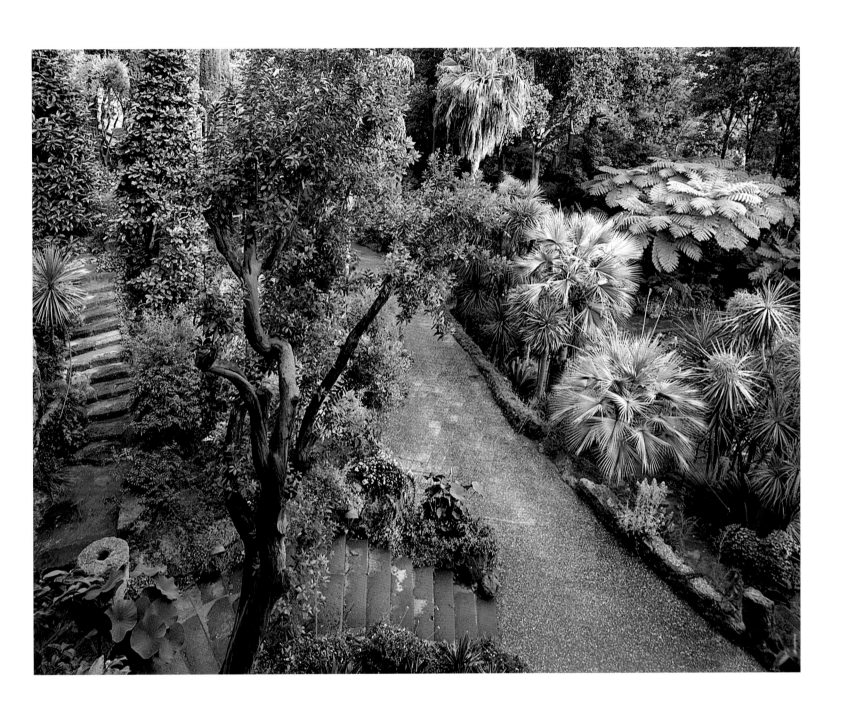

18 **Fog in Tropical Greenhouse** La Mortella

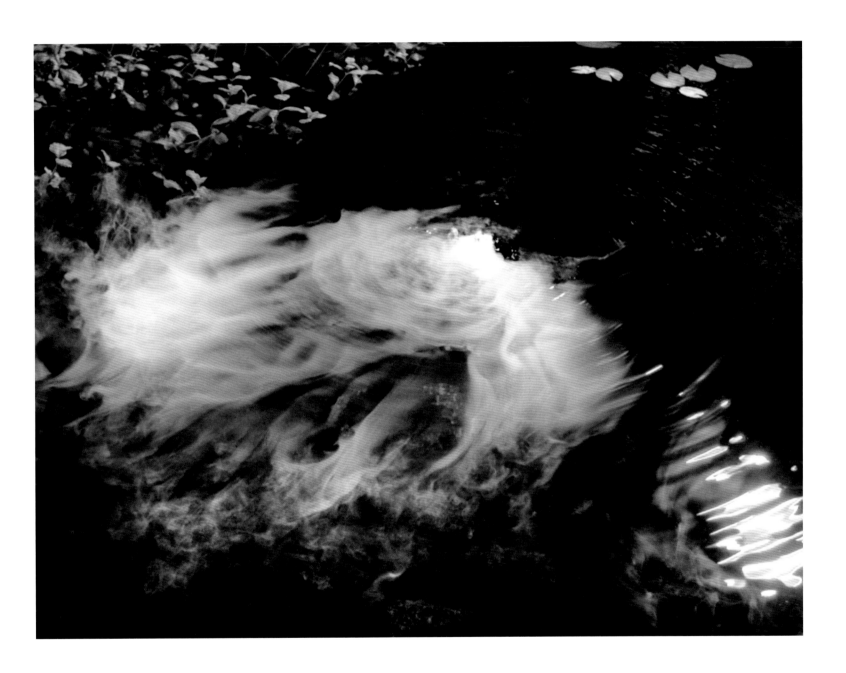

20

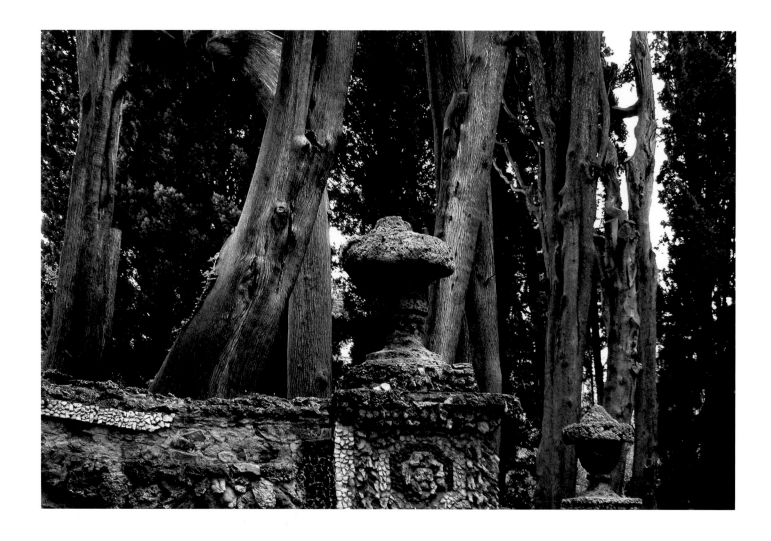

Grotto Wall with Urn against Trees La Gamberaia Roman Anchor Pulled from the Mediterranean Il Biviere

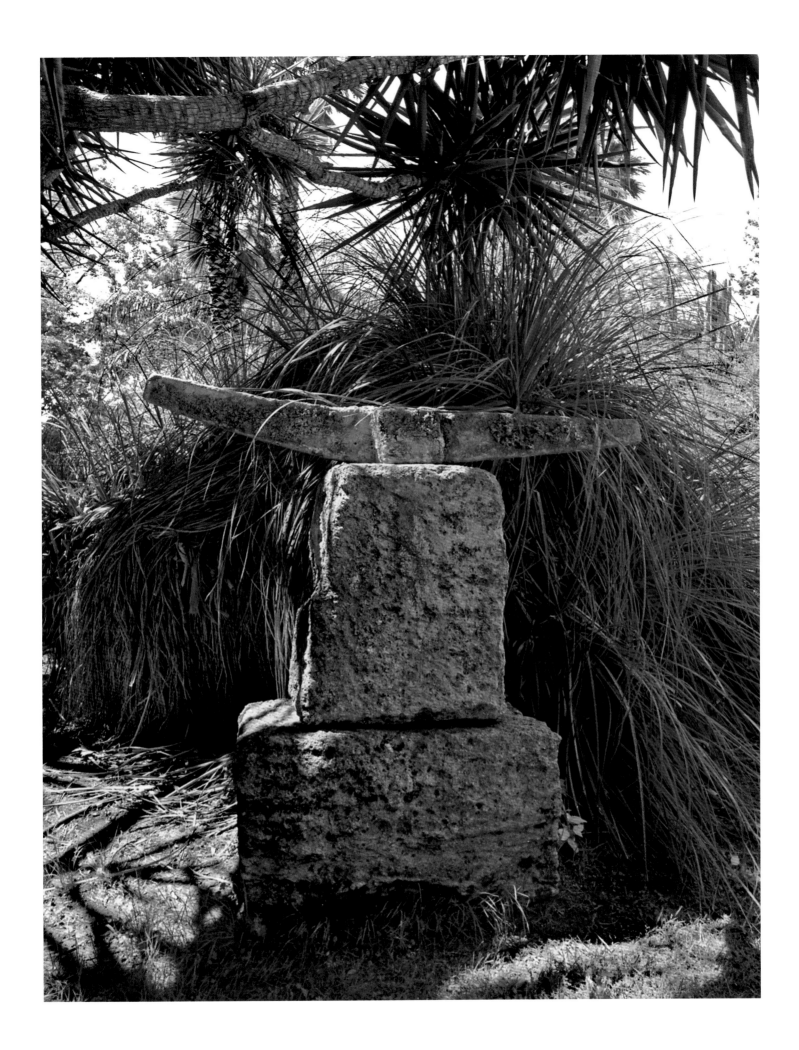

22 Cashmere Cypress Leaves Isola Madre

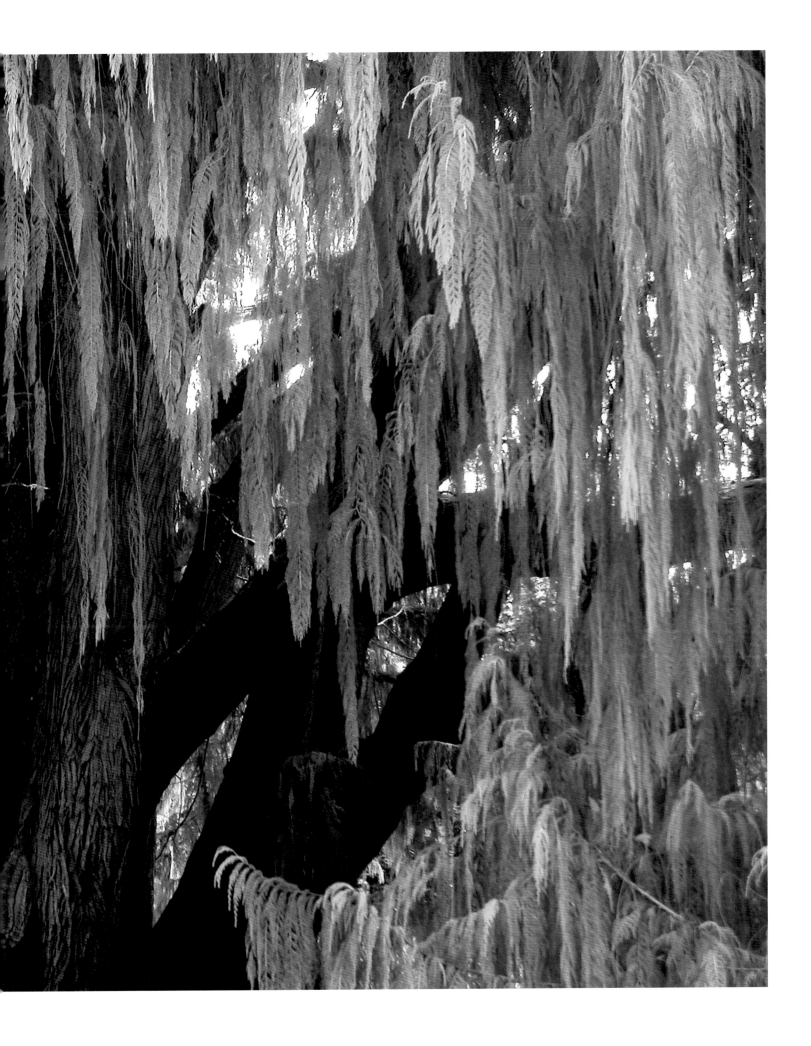

24 Gate and Window against Orange Wall Villa Reale

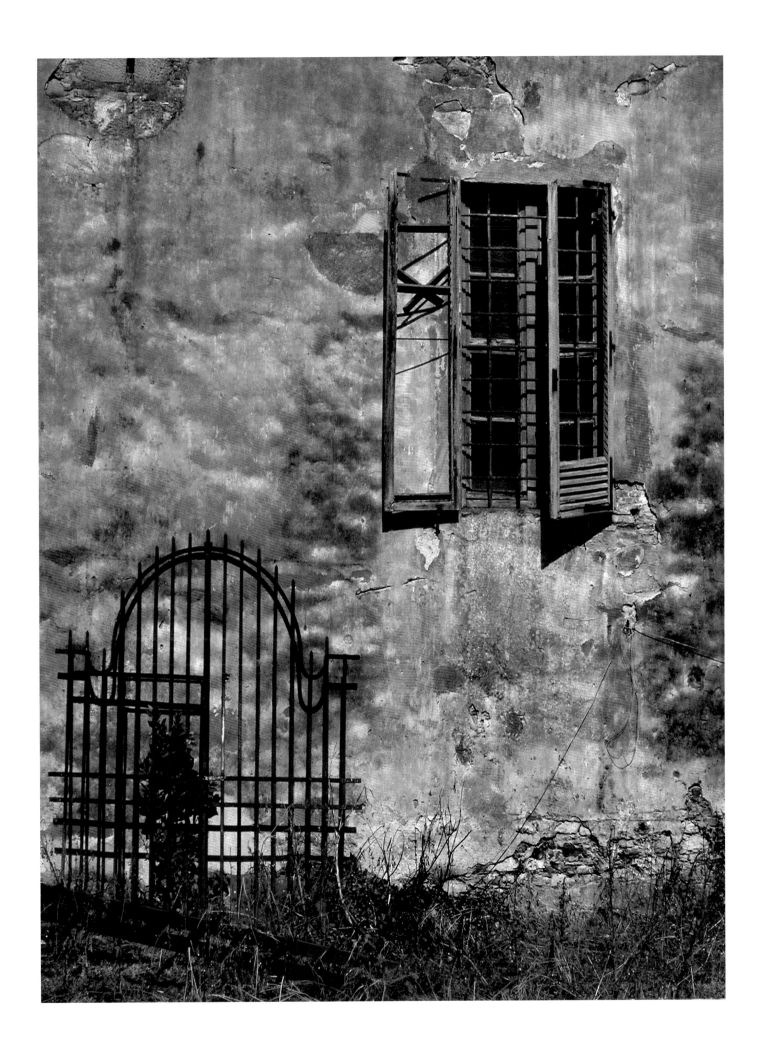

26 White Shrub against Vine Wall Isola Bella

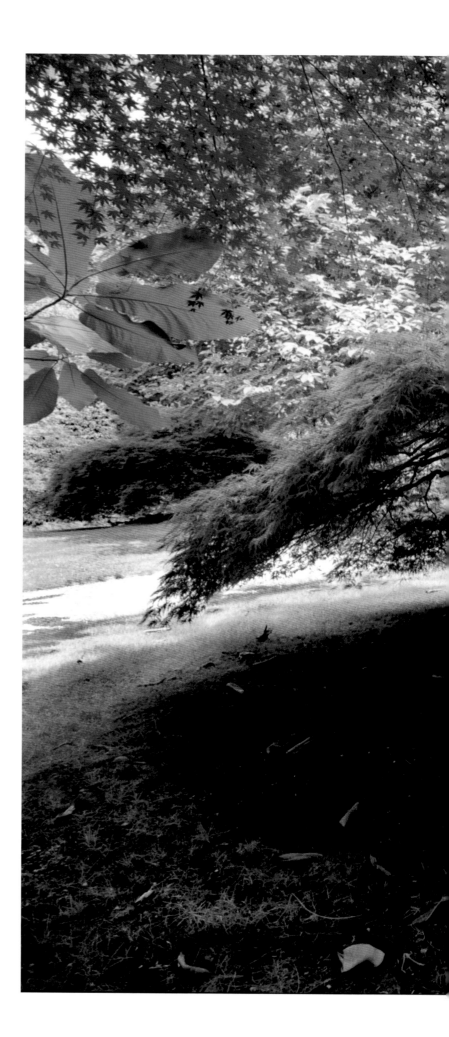

28 Japanese Maple Tree Isola Madre

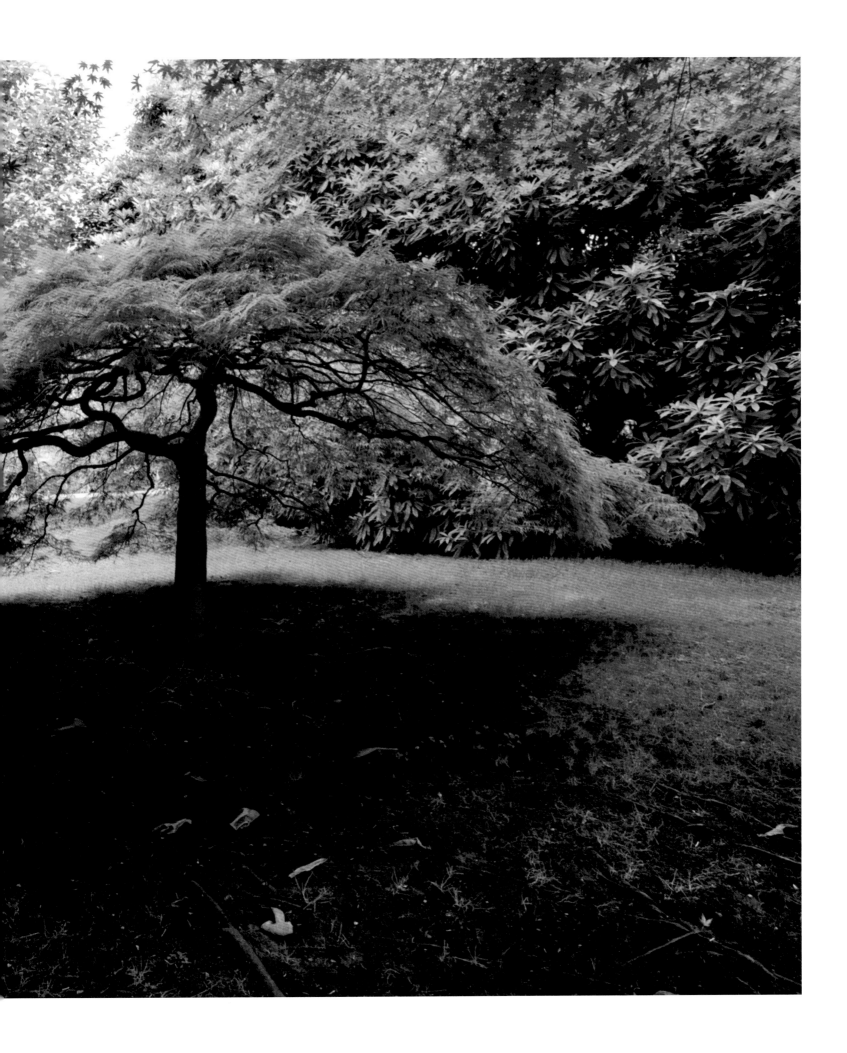

30 **Tree with Bench** Isola Madre

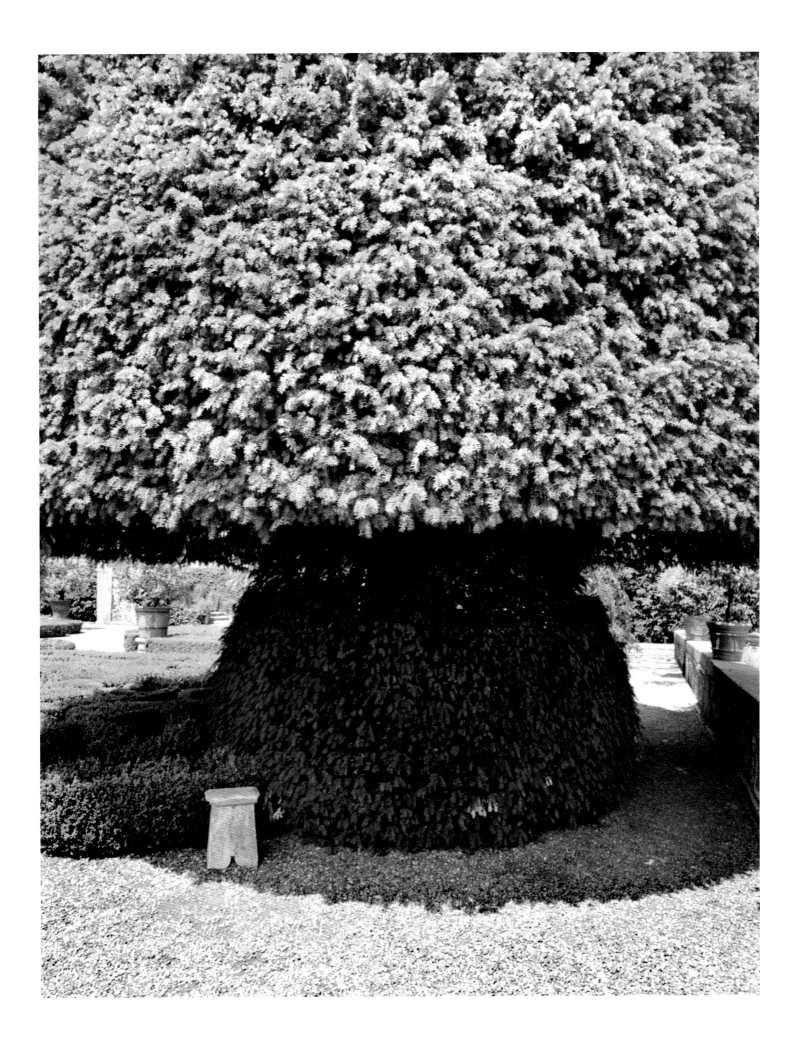

32 Cats in the Window with Succulent Il Biviere

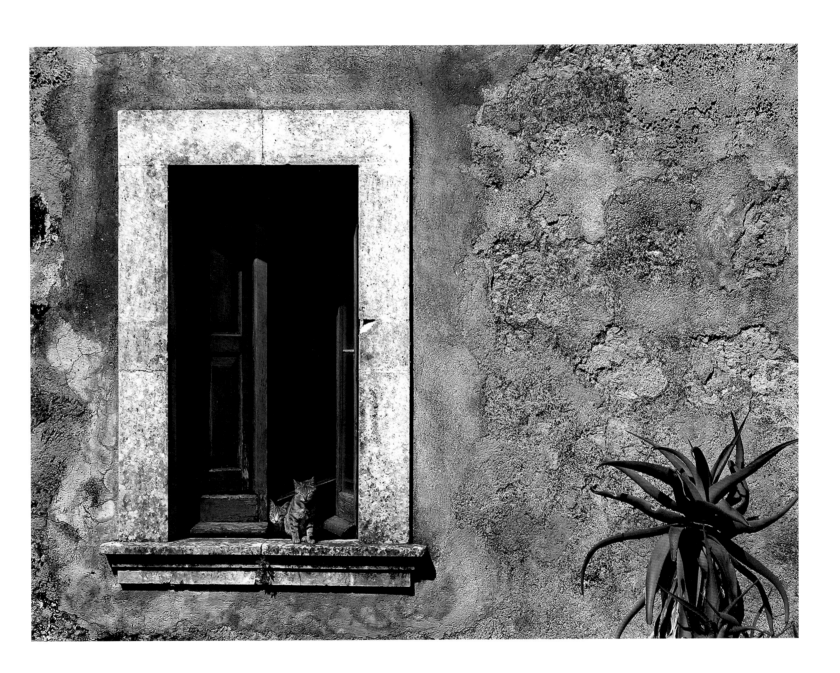

34 Roman Bath Tub and Chapel Villa Arvedi

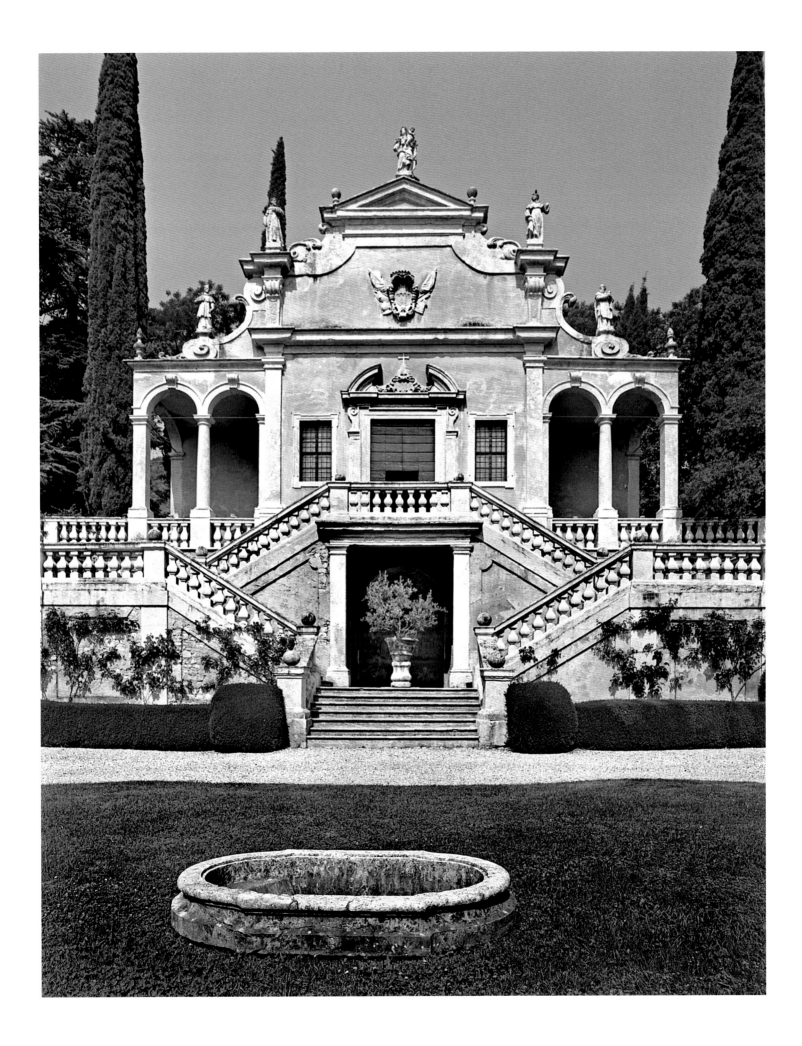

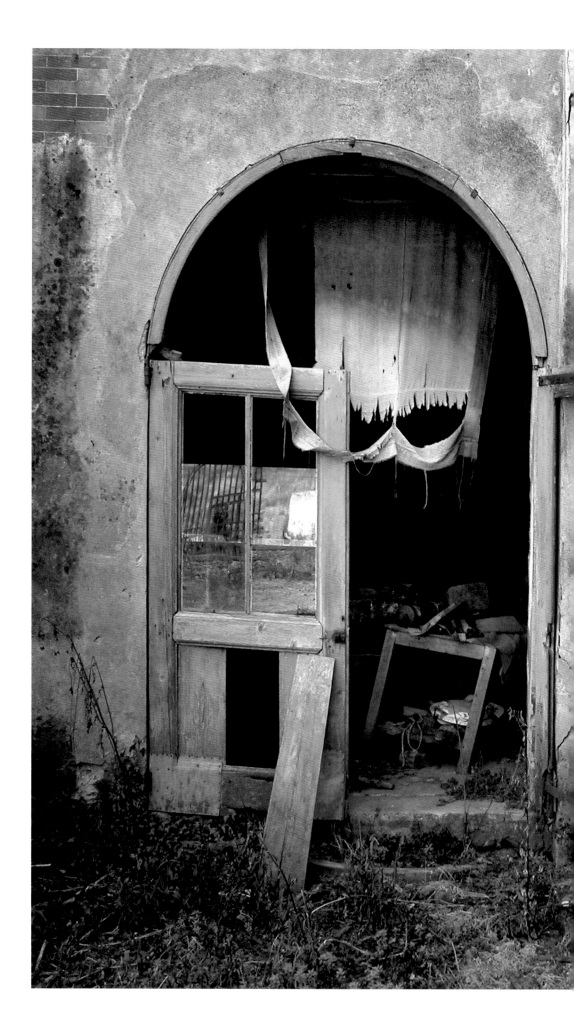

36 **Two Green Doors** Villa Reale

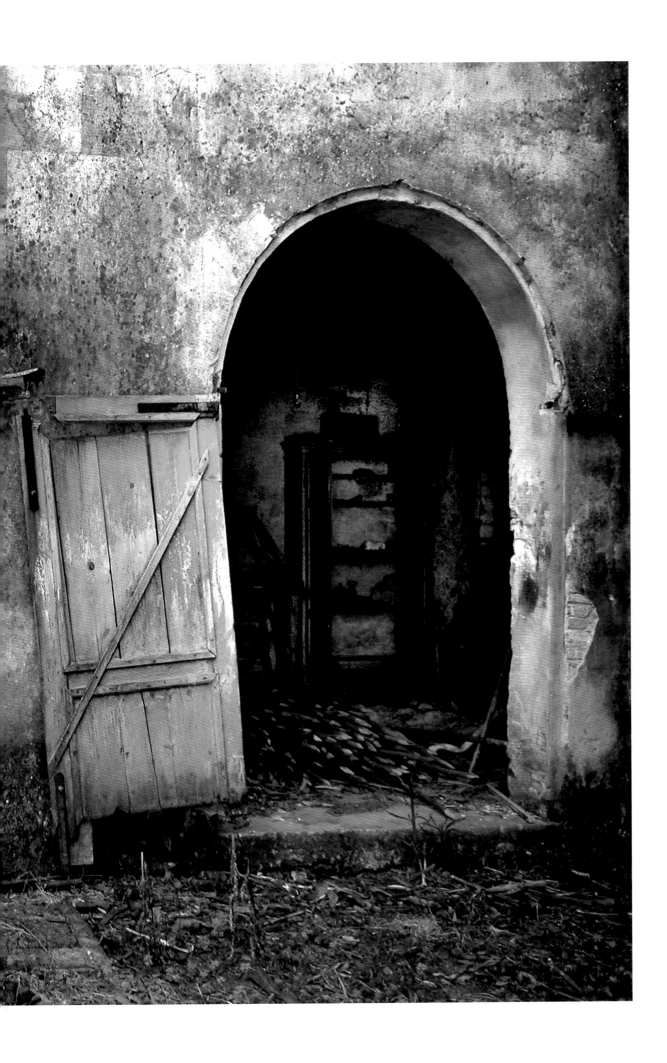

38 **William Walton's Grave Marker** La Mortella

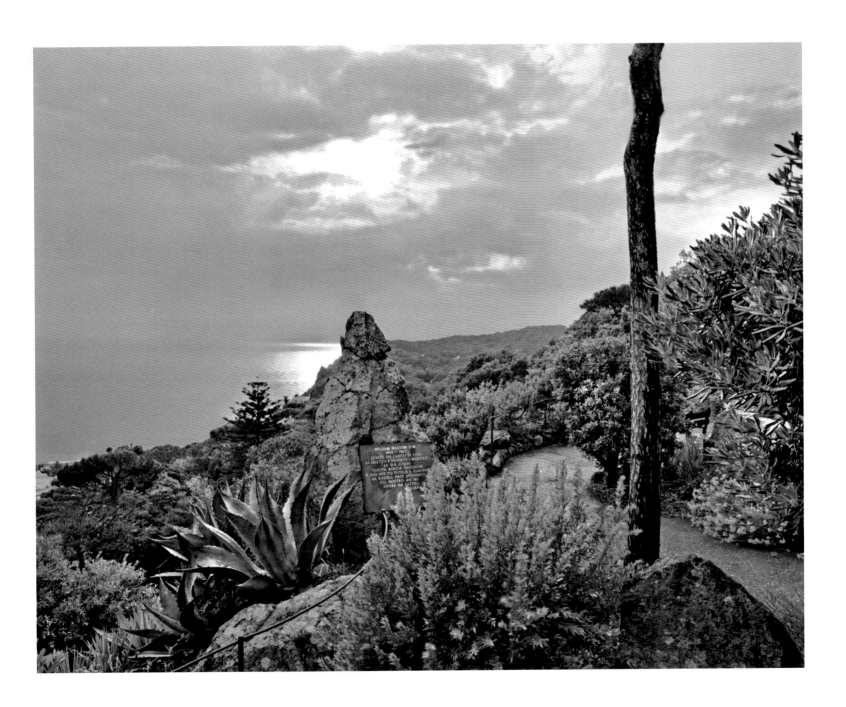

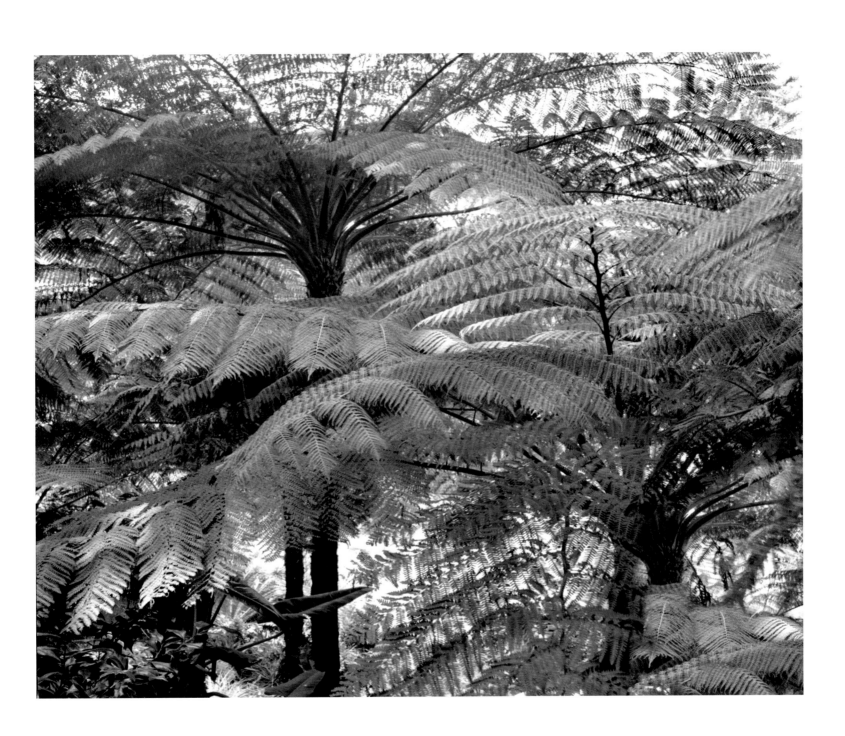

42

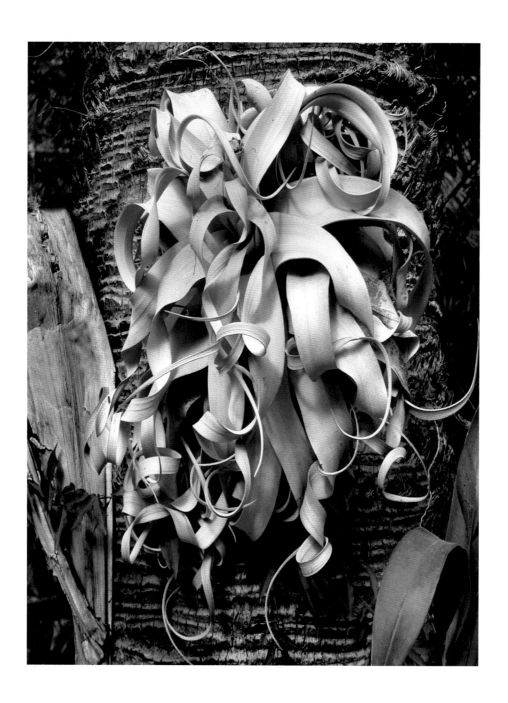

Tillandsia Air Fern from South Mexico La Mortella Emerald Orchid with Leaf La Mortella

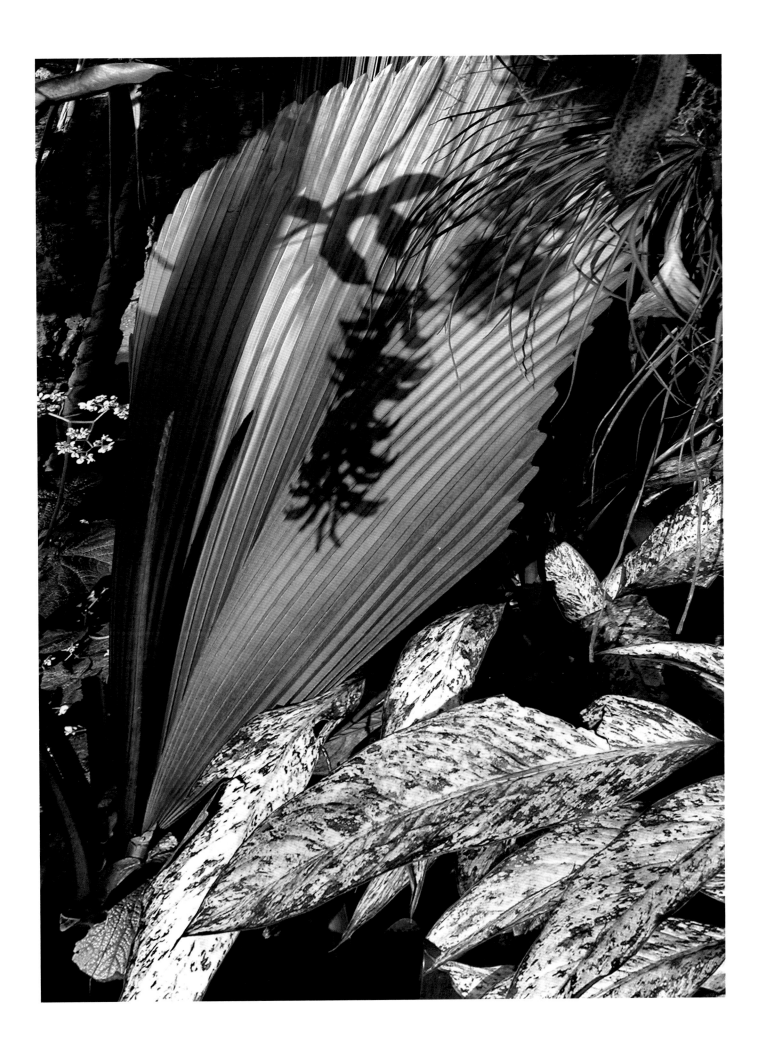

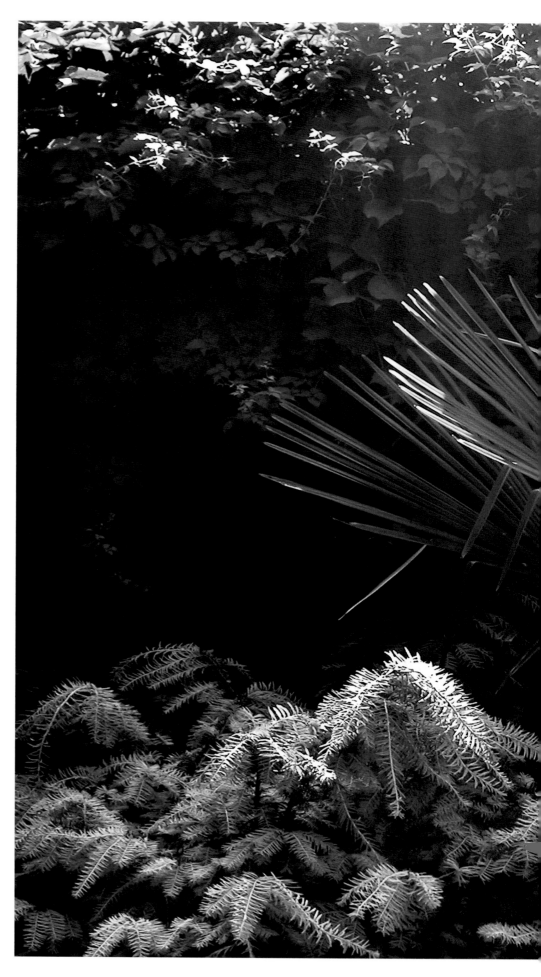

Light Rays through the Palm Isola Madre

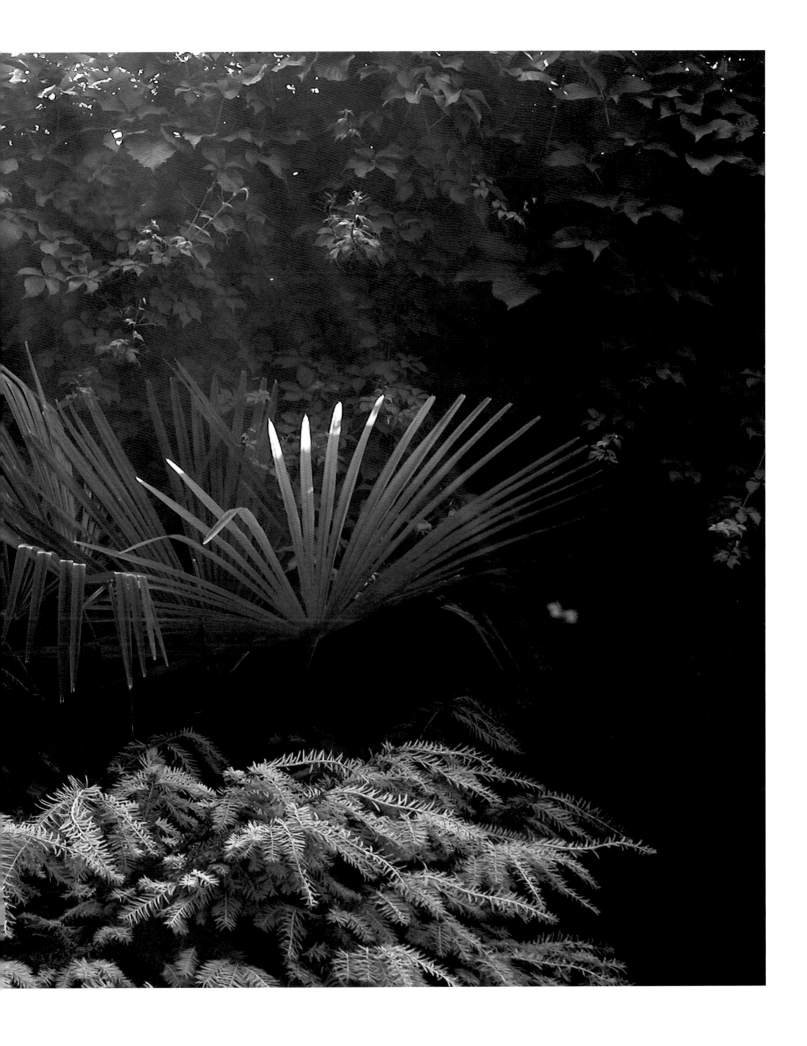

46 **Tree against Stucco Wall** La Gamberia

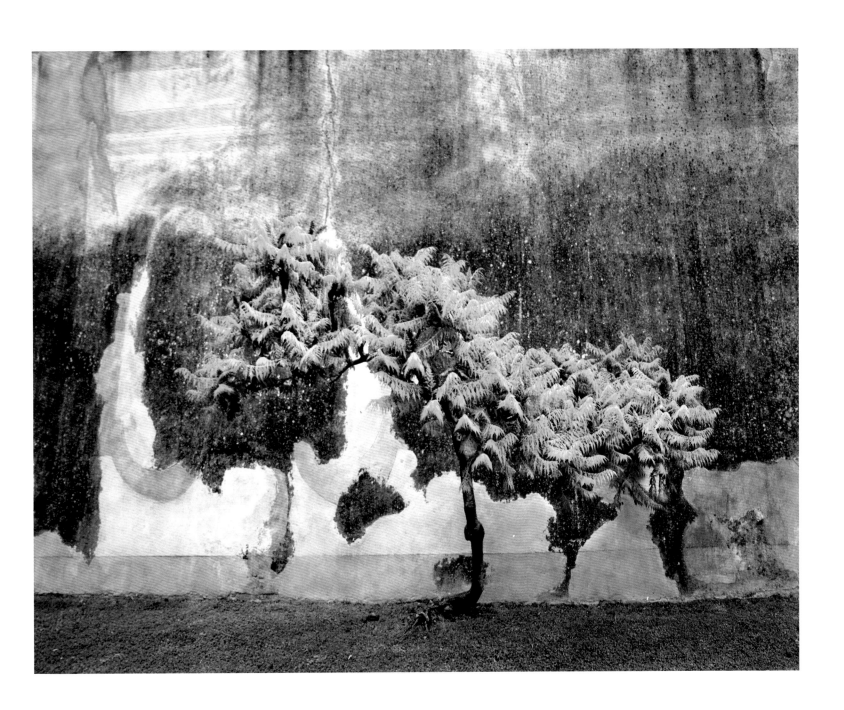

48

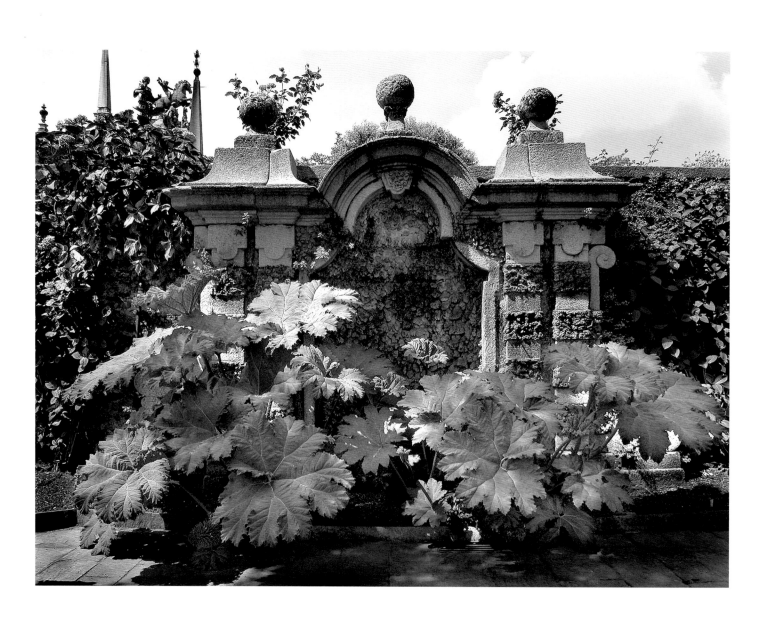

Giant Rhubarb against Pilars Isola Bella Leaf Detail in the Sun Isola Bella

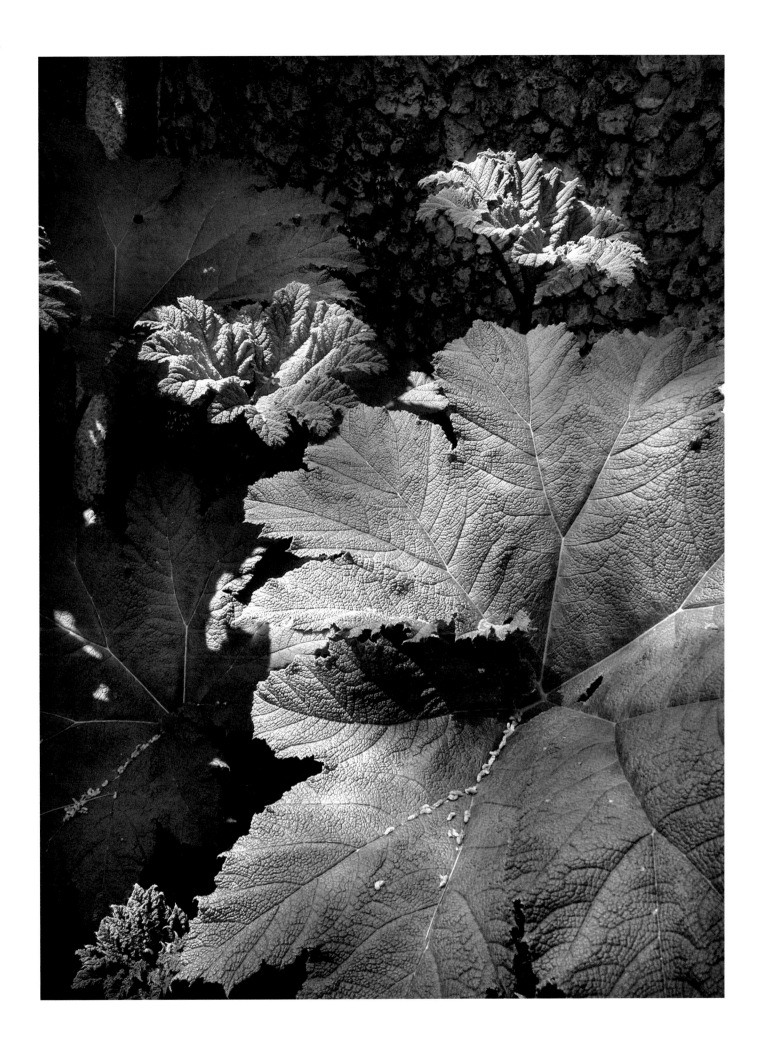

50

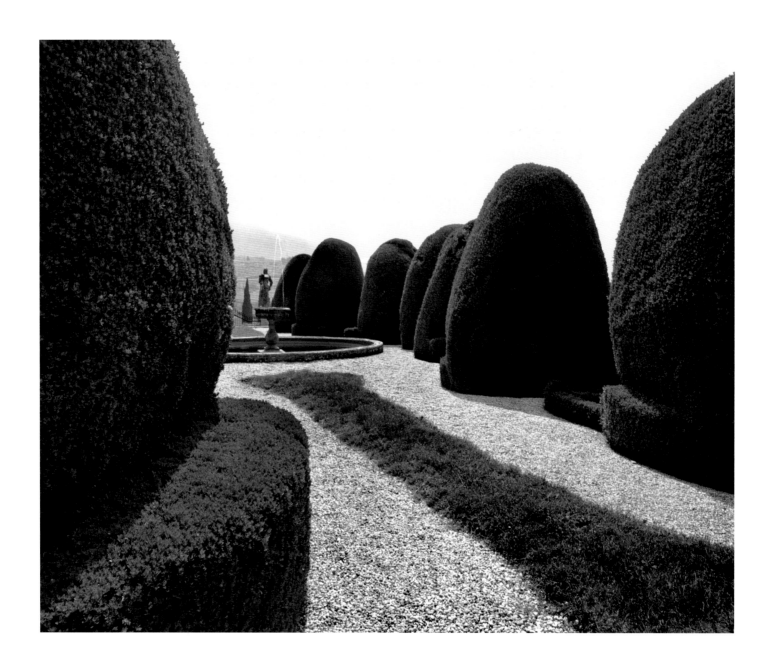

Formal Gardens with Fountain Villa Arvedi

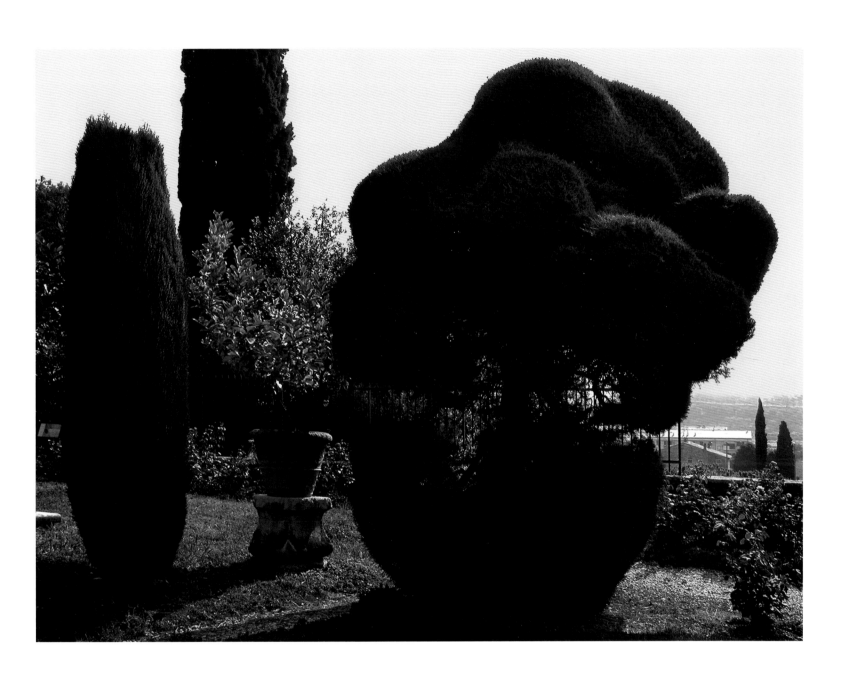

Dying Tree with Olive in Pot Villa Arvedi

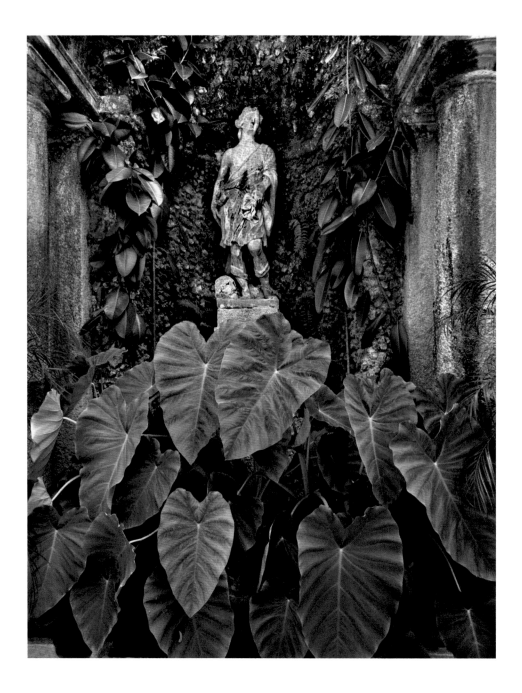

52

Statue at Bottom of Staircase Isola Bella Small Fountain with Rill La Mortella

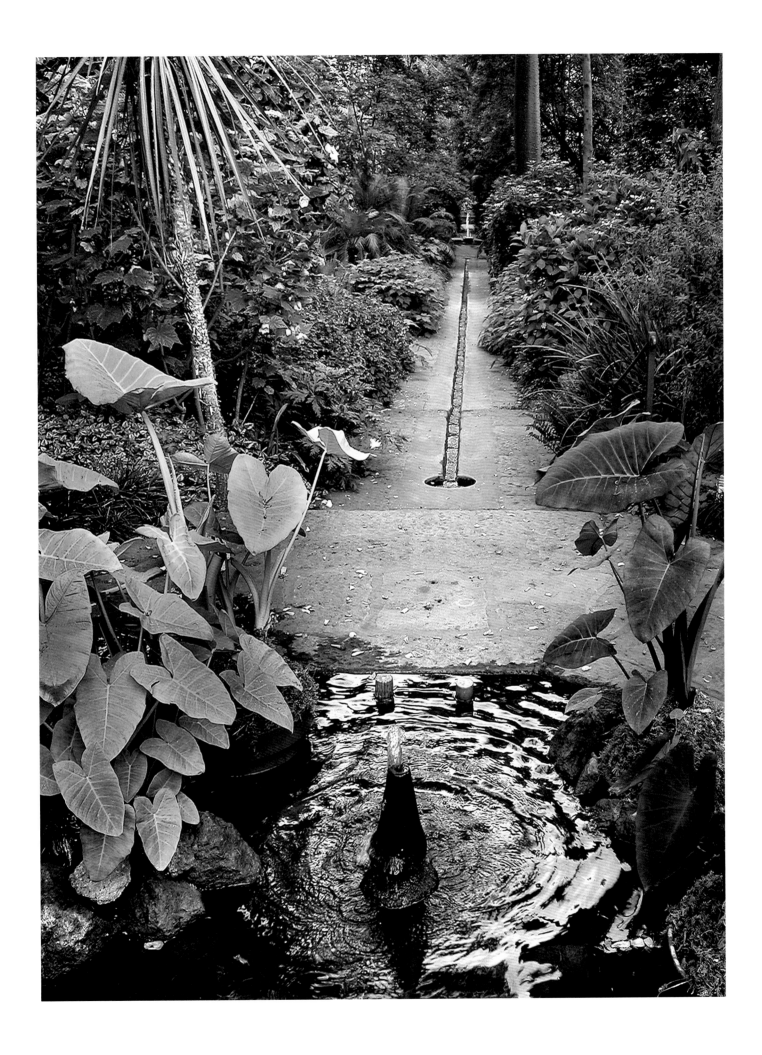

54 View through the Yucca Grove Il Biviere

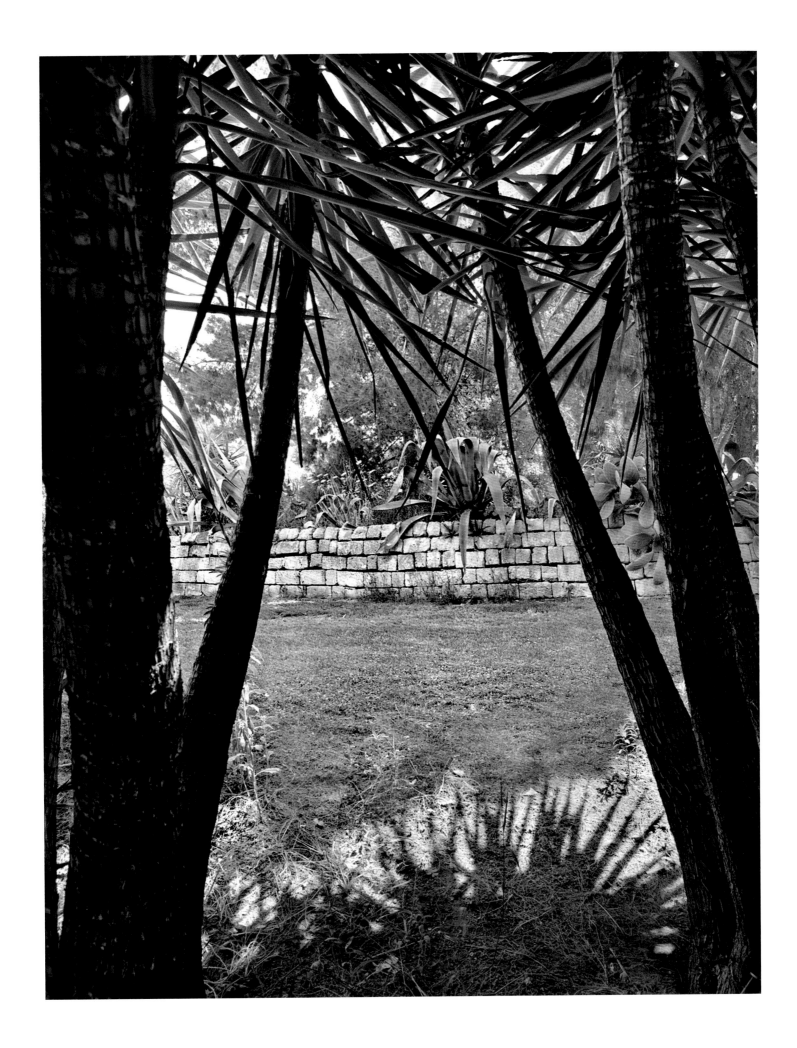

56 Window near Entry Il Biviere

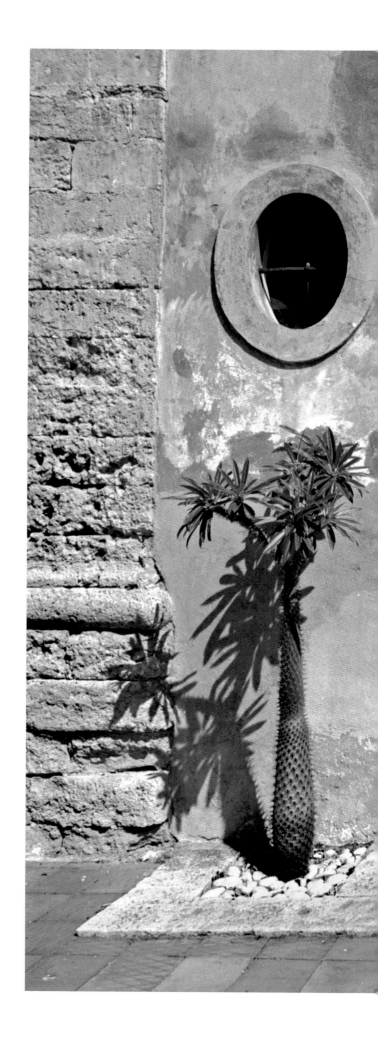

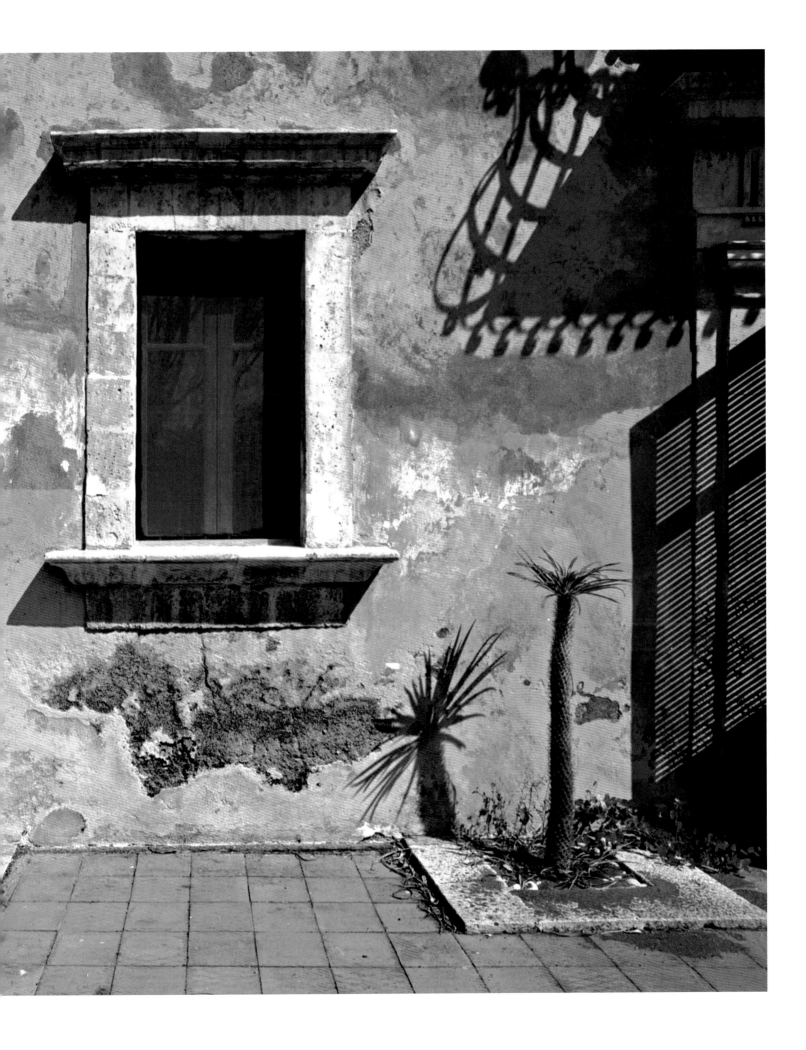

58 **Walk to North Wall** Giardino Giusti

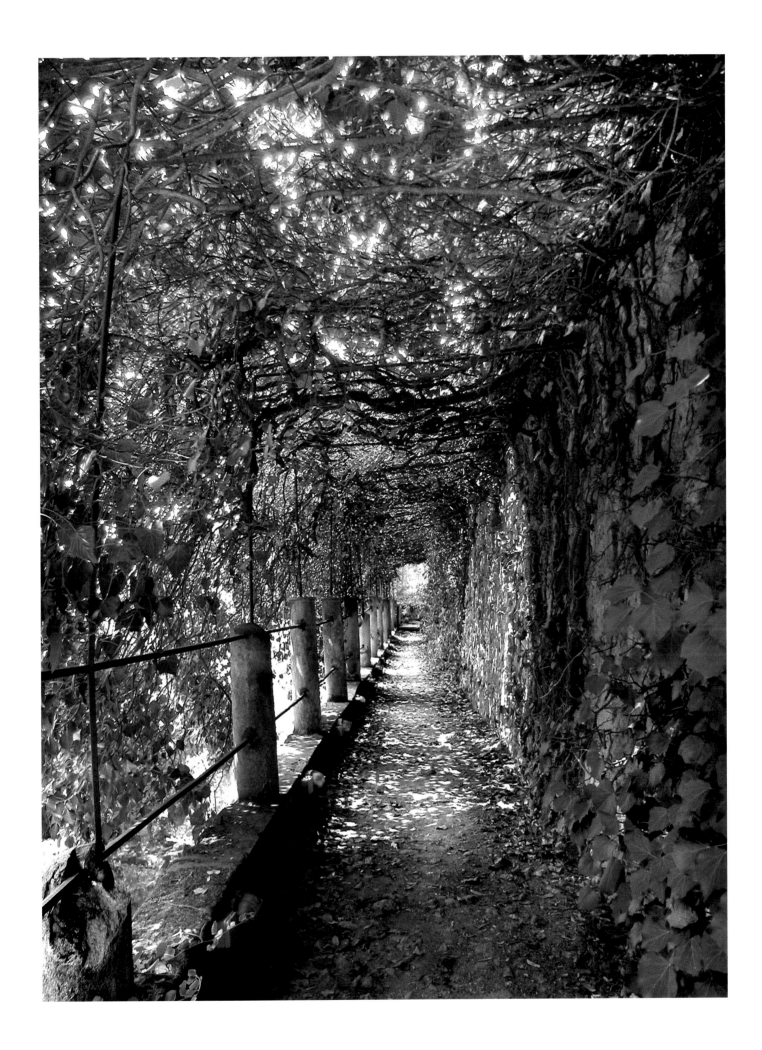

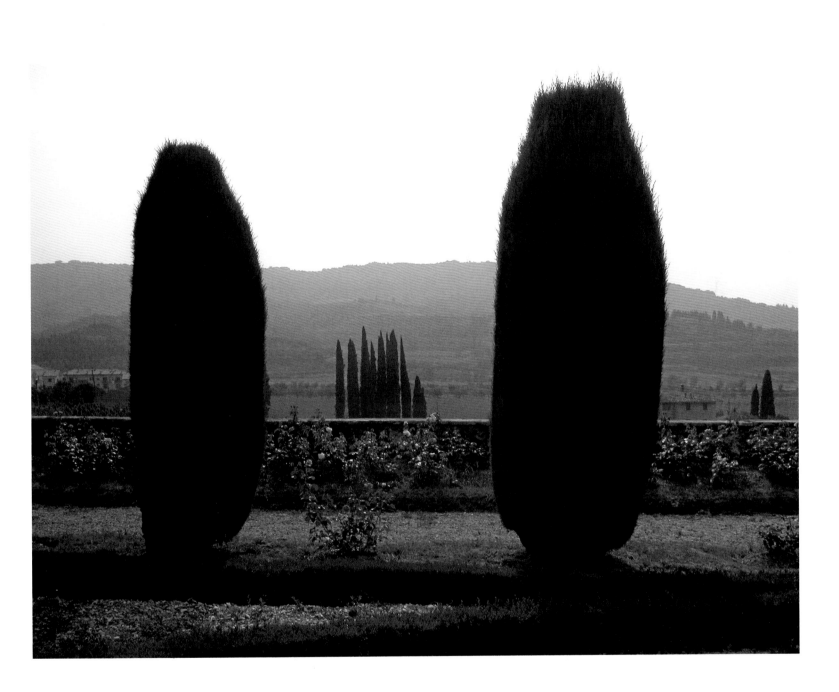

62 **Amazon Greenhouse with Mask** La Mortella

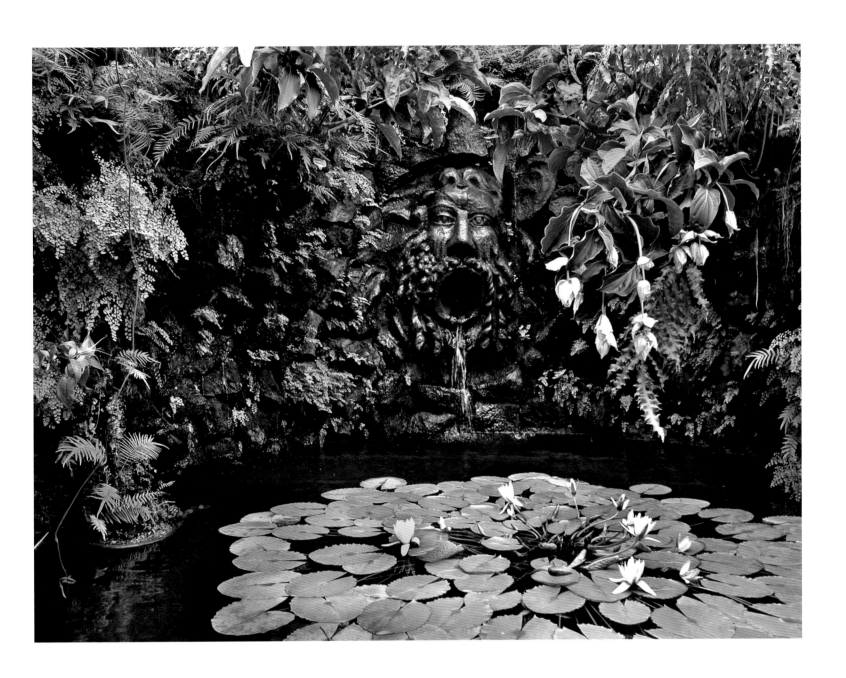

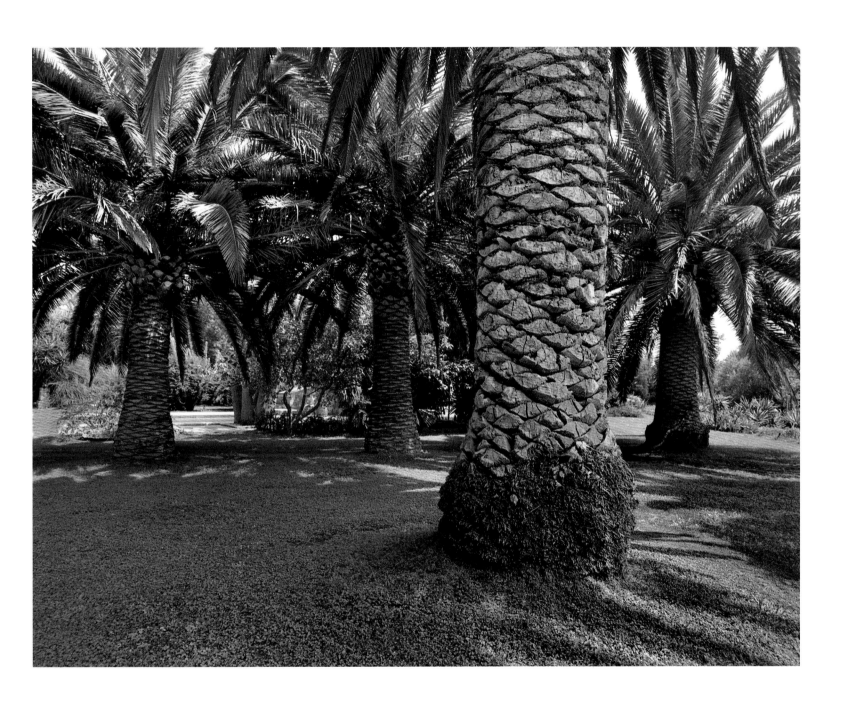

66 Stairway to Green House Isola Bella

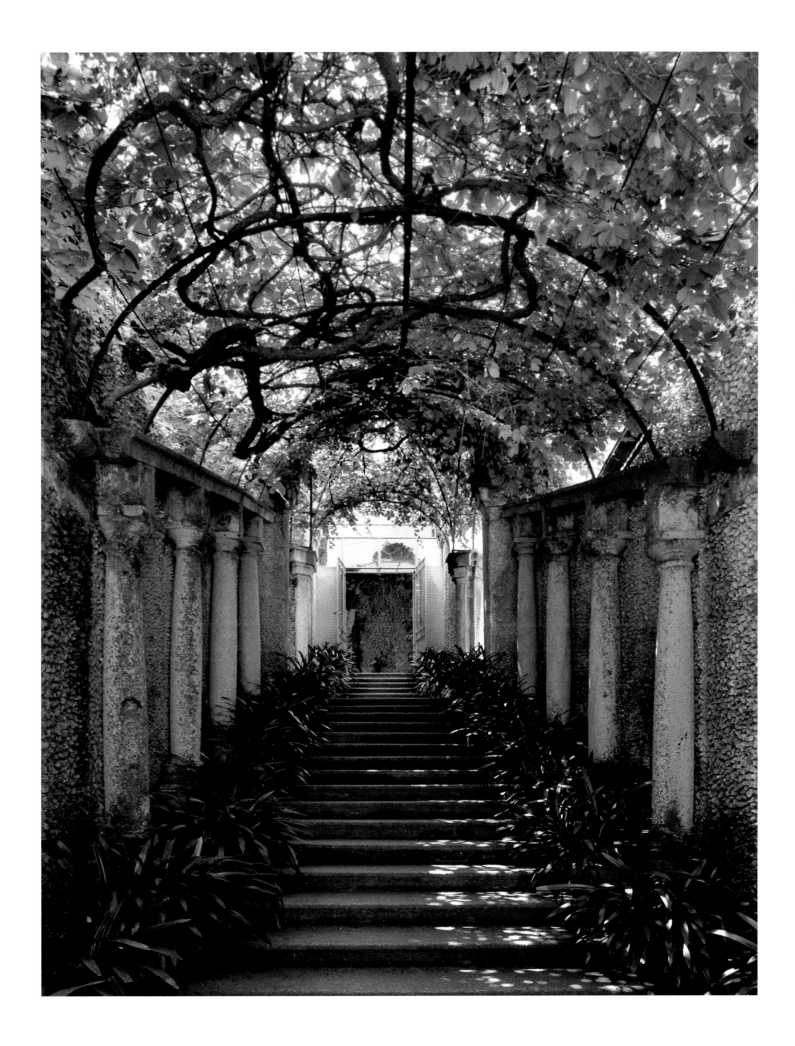

68 Bishop's Hidden Door in Chapel Villa Arvedi

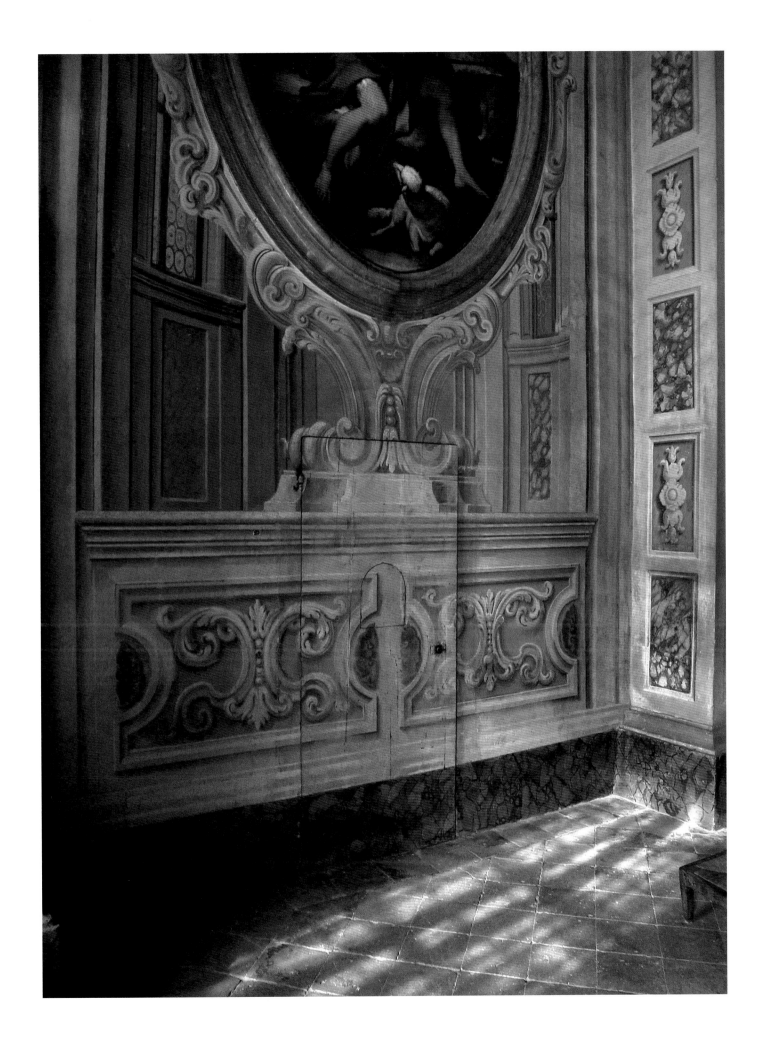

70 **Trail with Fern** Isola Madre

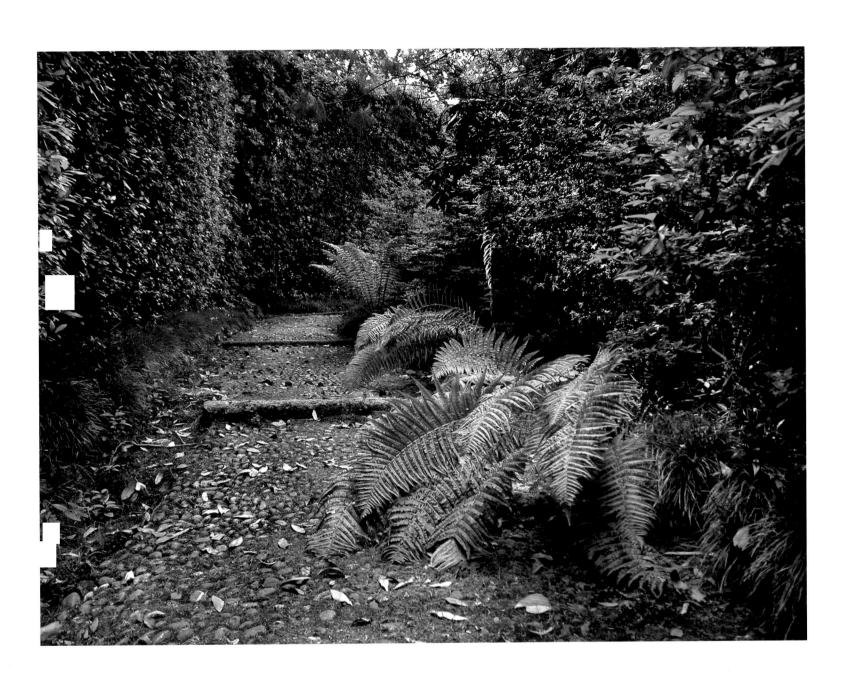

72 Cheese Storage at Castello Villa Gino Pateroo Castello

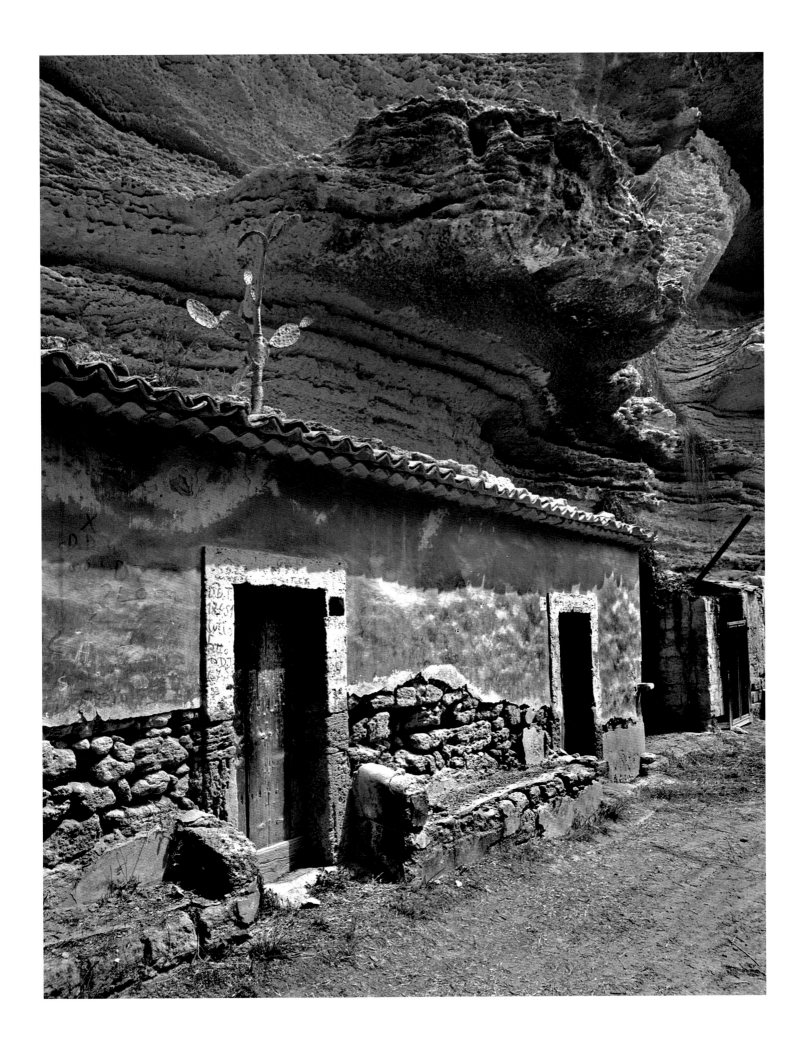

74 **Staircase with Hydrangeas** La Gamberaia

76 **Griffin at the Main Lake** Boboli

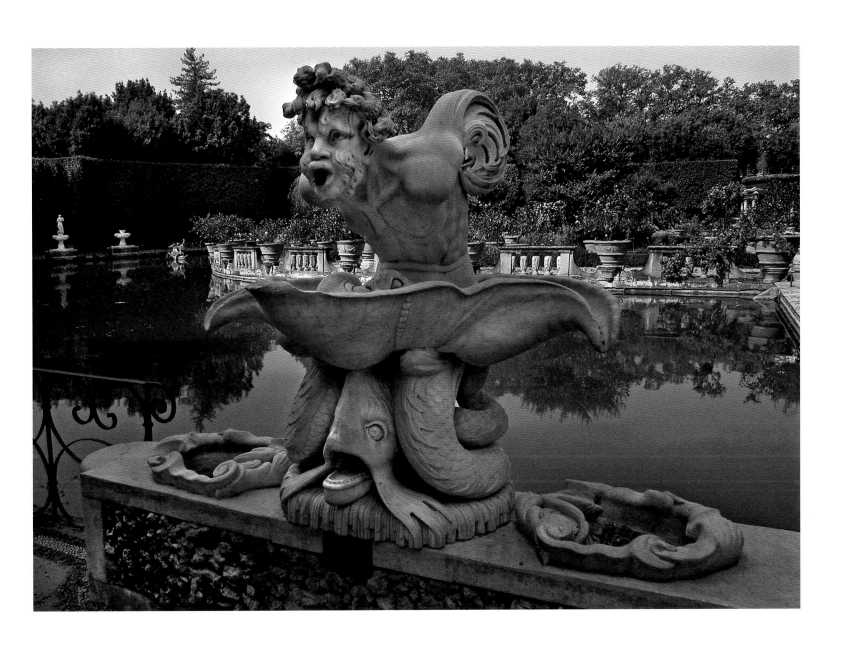

78 **Villa Entry to Gardens** Valsanzibio

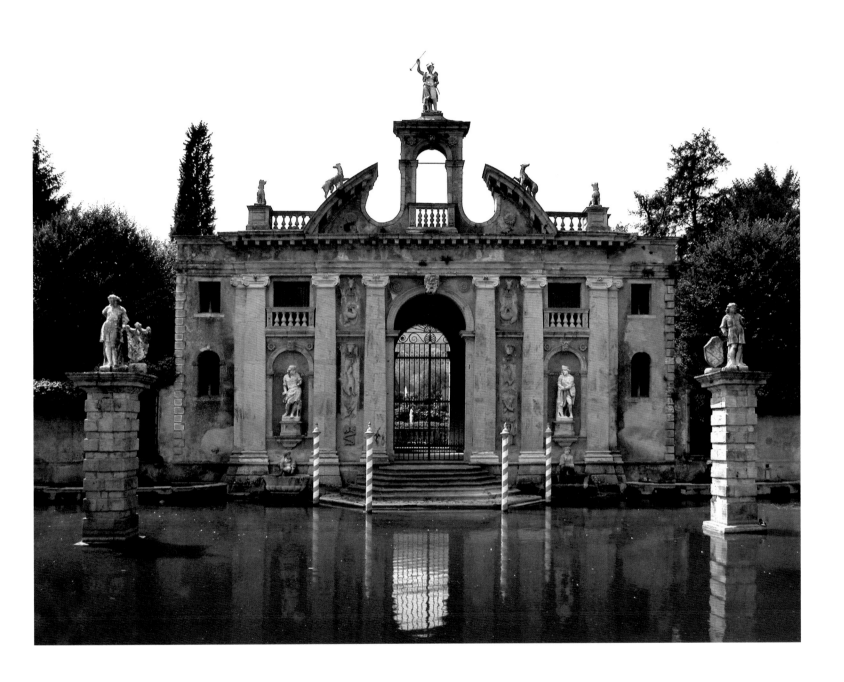

80 Statue behind Hydrangeas Isola Bella

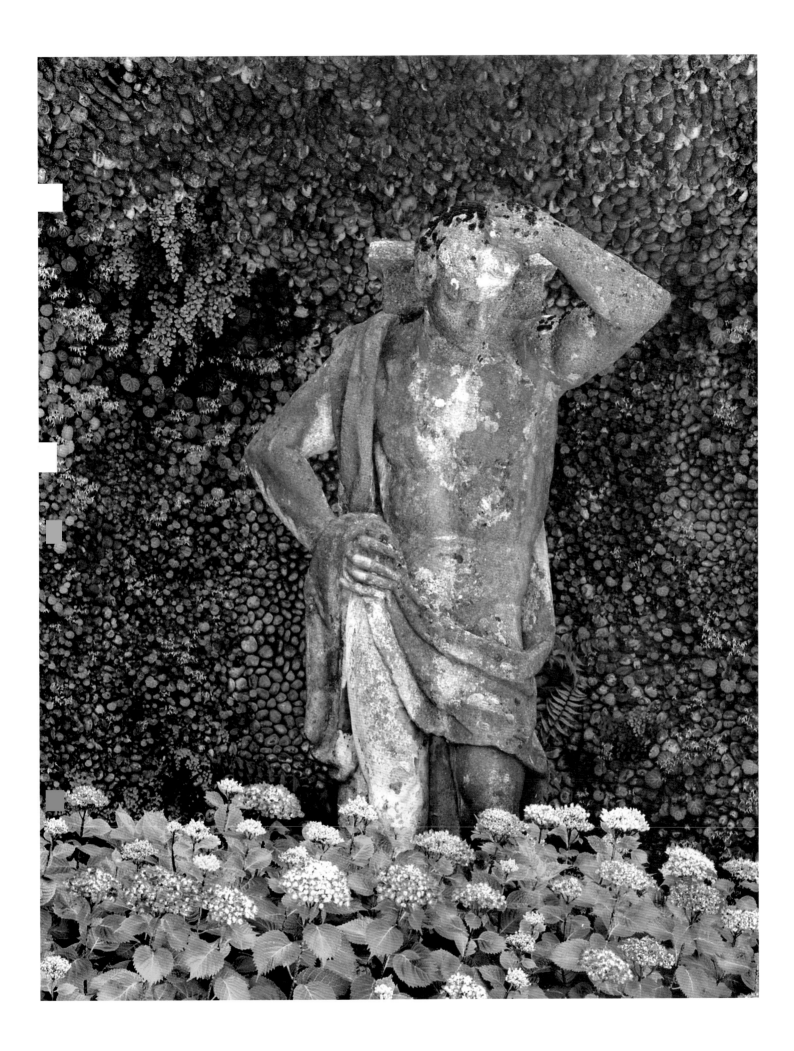

82 Covered Walkway Boboli

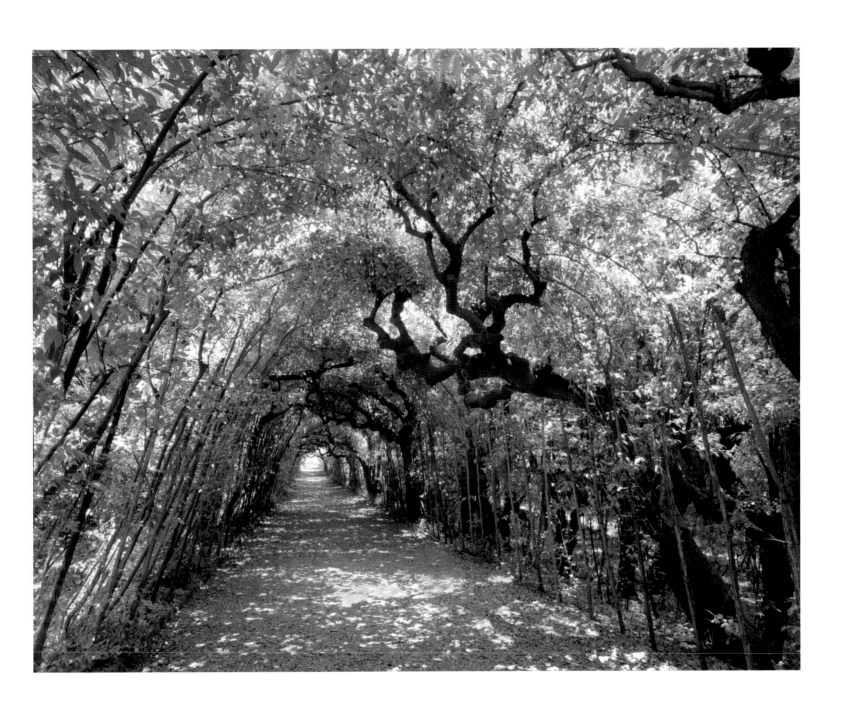

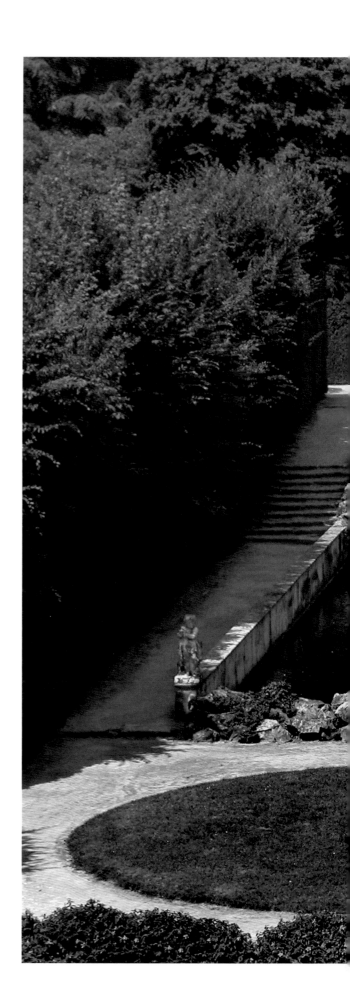

84 Entrance Pond with Fountains Valsanzibio

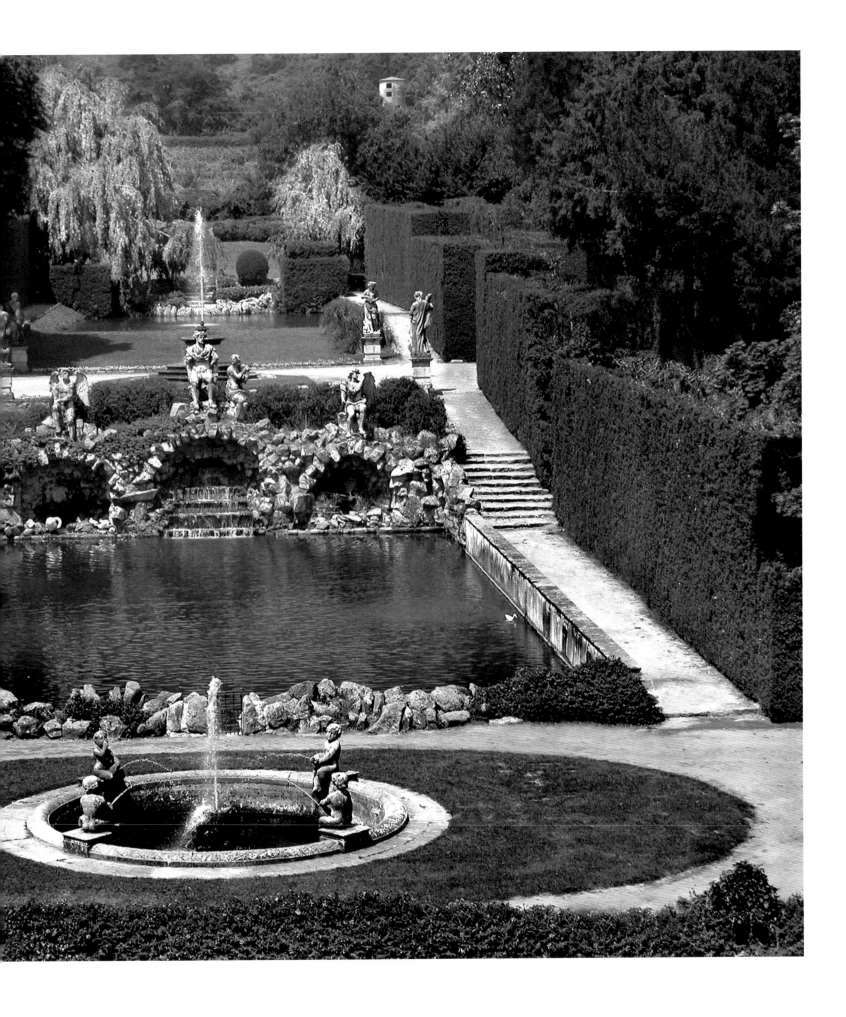

Stream with Ferns Valsanzibio

Yellow Lilly in Pond La Landriana

88 Abandoned Aviary Villa Arvedi

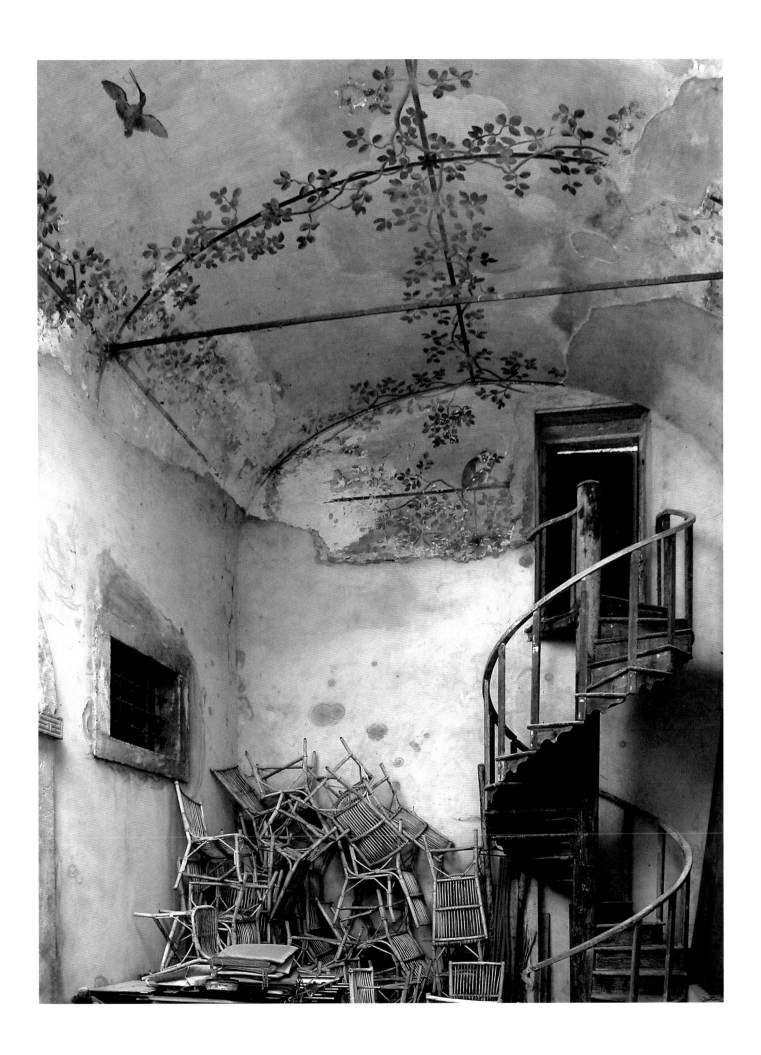

90 **Grotto** Villa Reale

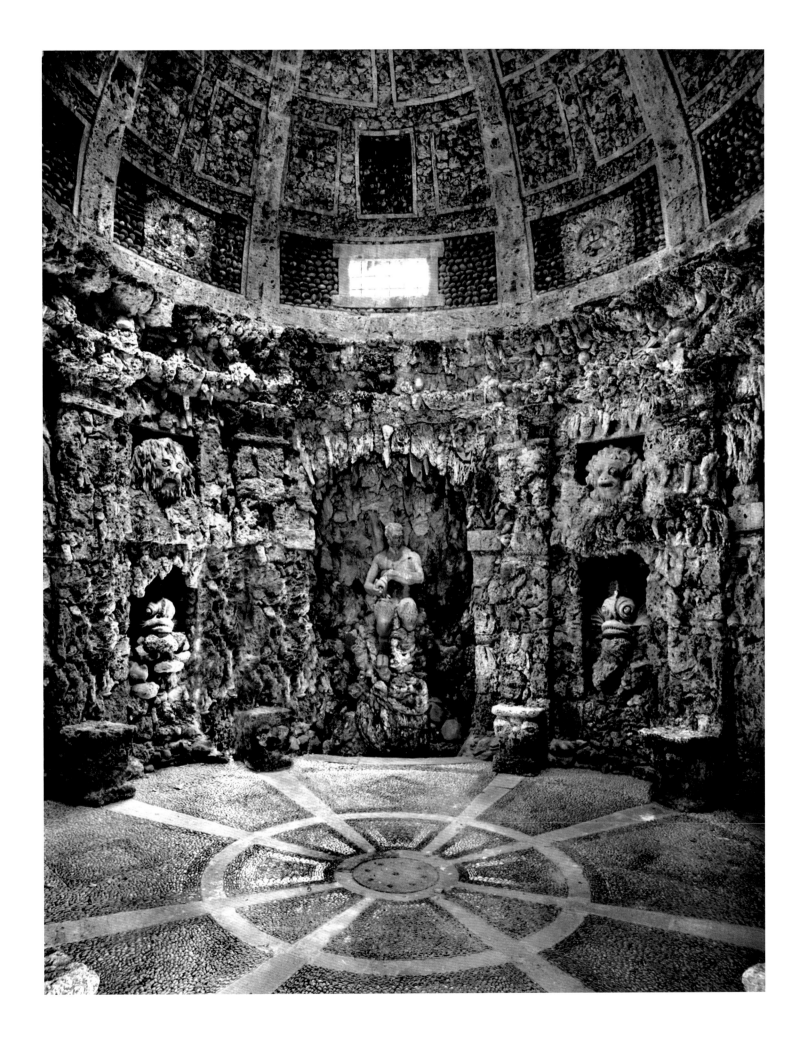

92 Lawn through Winter Garden Window Villa Arvedi

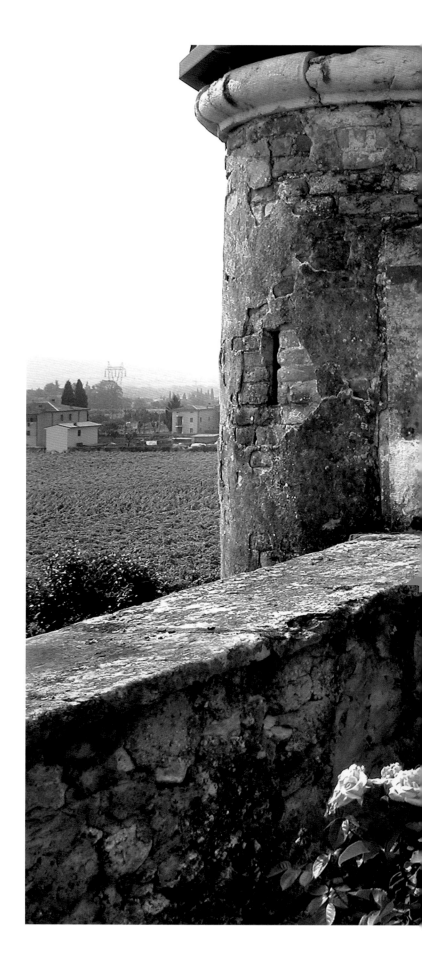

94 Corner Guard Tower Villa Arvedi

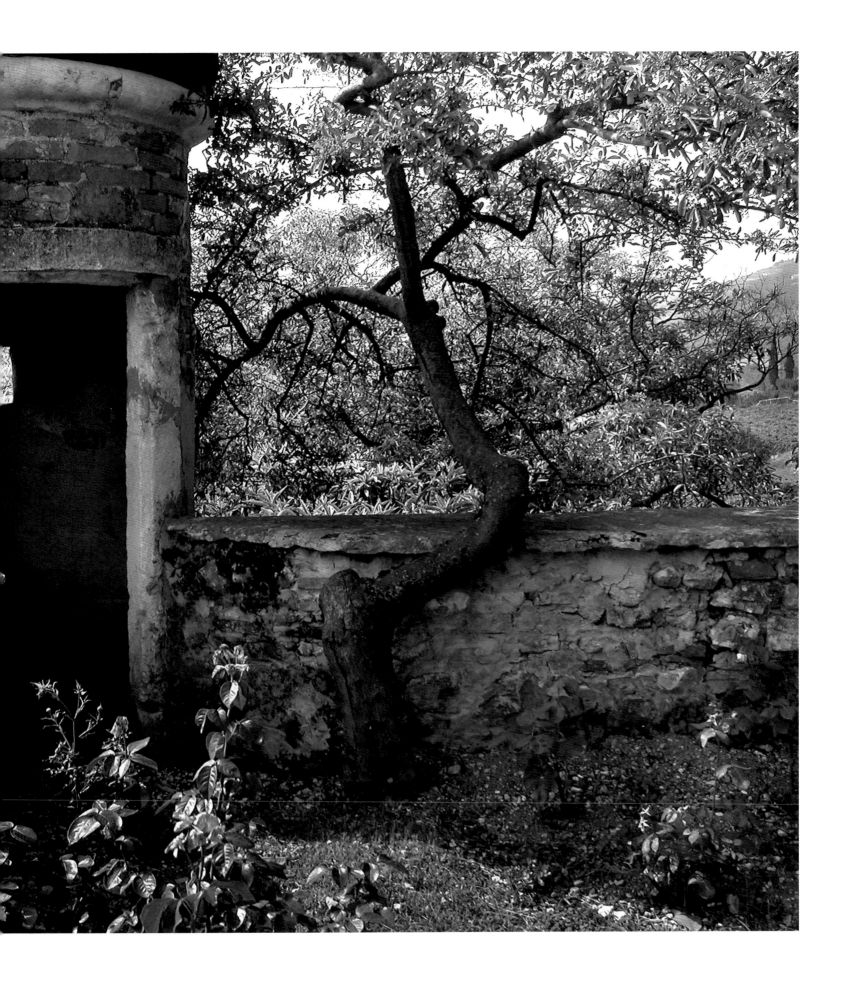

96 **Broken Pots against Wall** La Gamberia

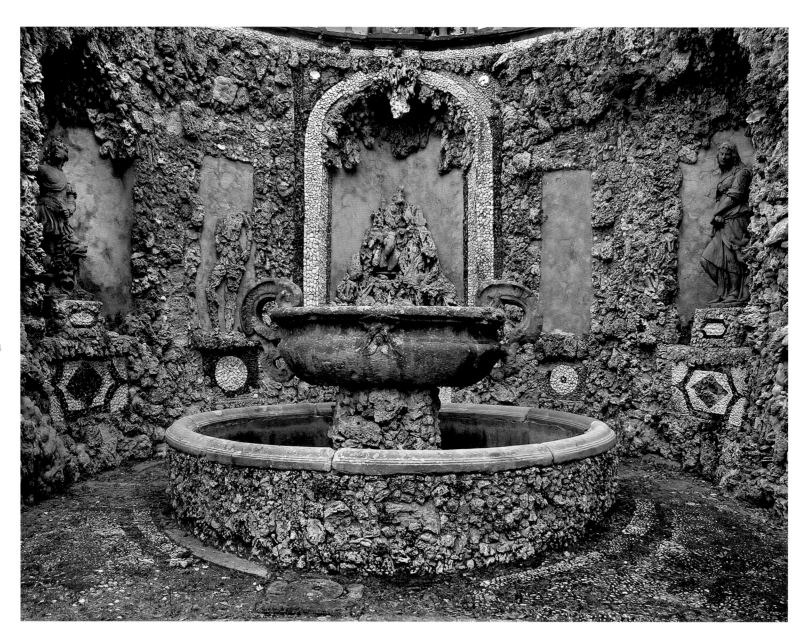

98

Terracotta Statues and Fountain La Gamberaia

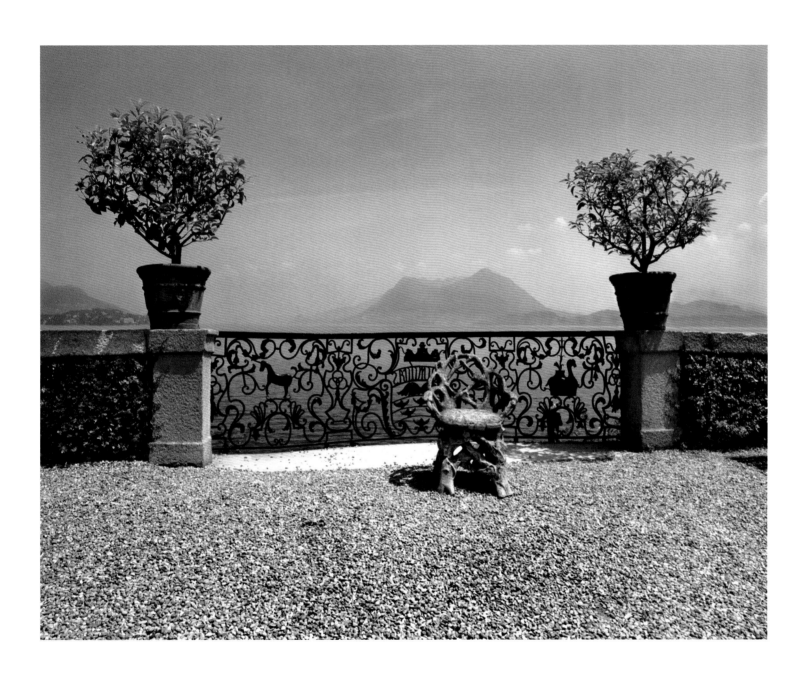

Stone Chair with View Isola Bella

100 **Stables and Courtyard** Villa Reale

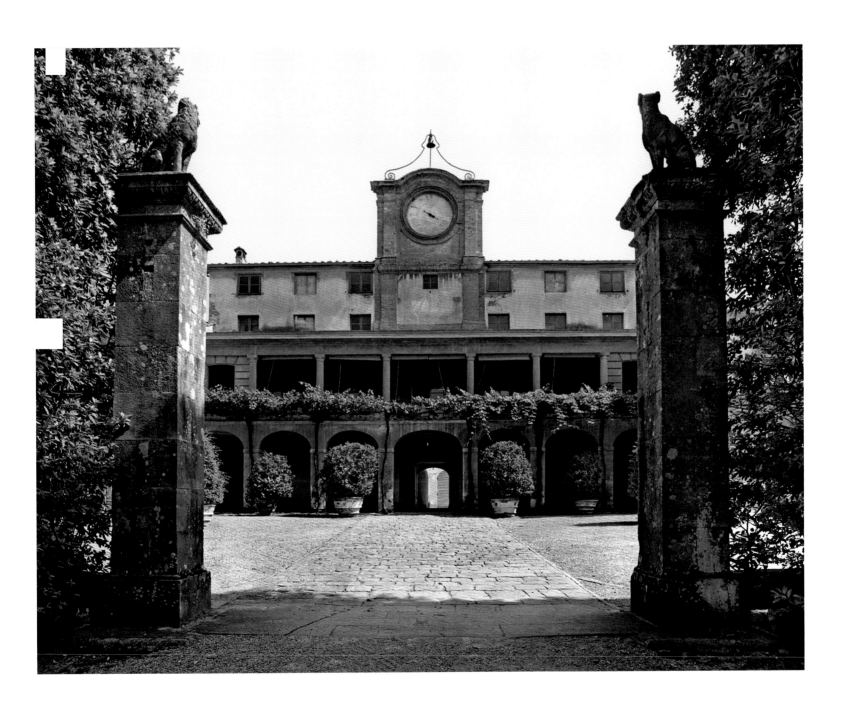

102 **Tree Canopy** Bobili

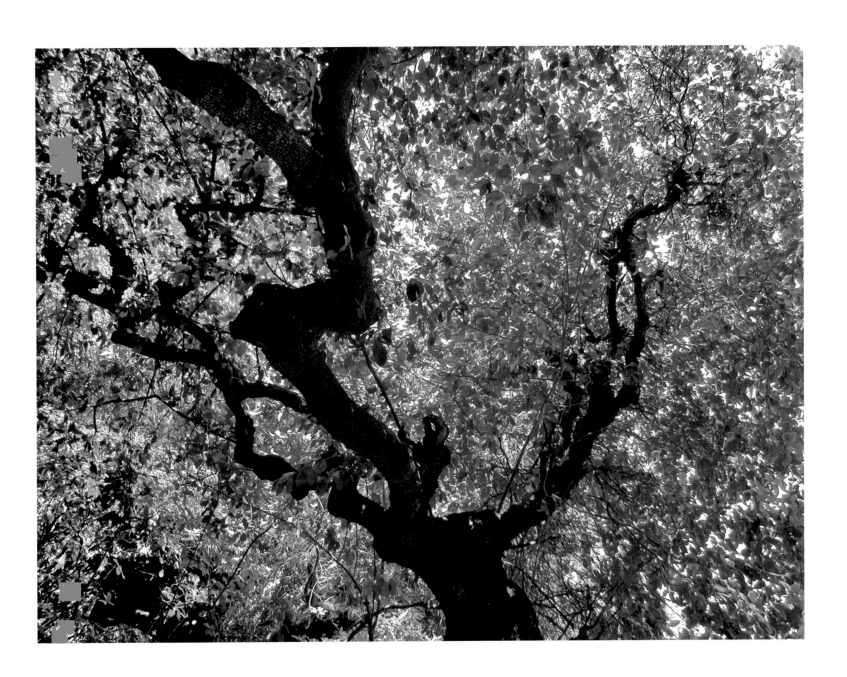

104 View from the Walled Patio at Sunset Isola Bella

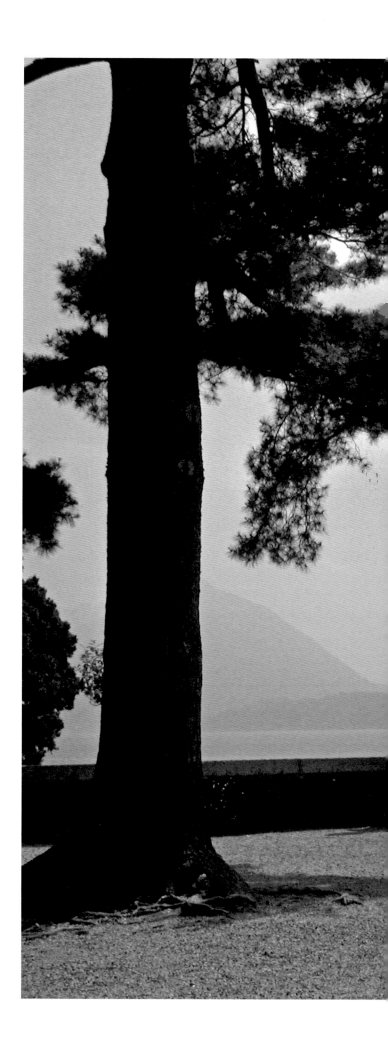

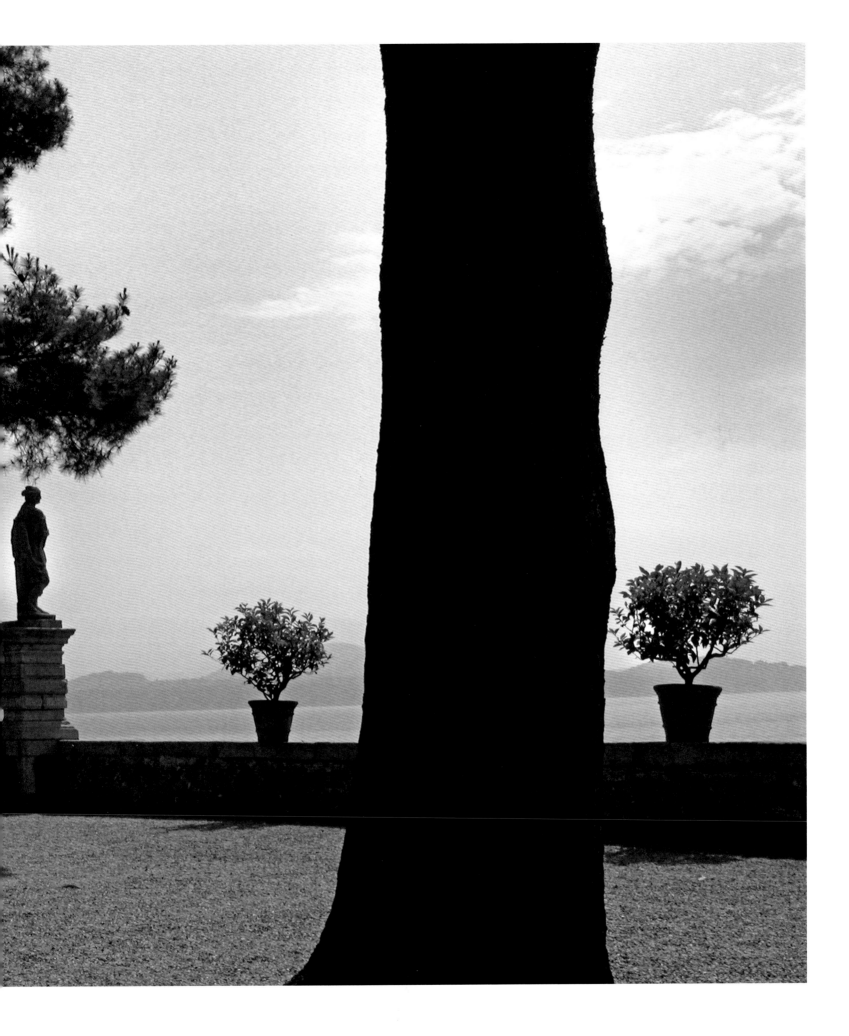

Trail with Dead Flowers Isola Bella

Trail to Abandoned Exit Giardino Giusti

108 Fresco on Chapel Ceiling Villa Arvedi

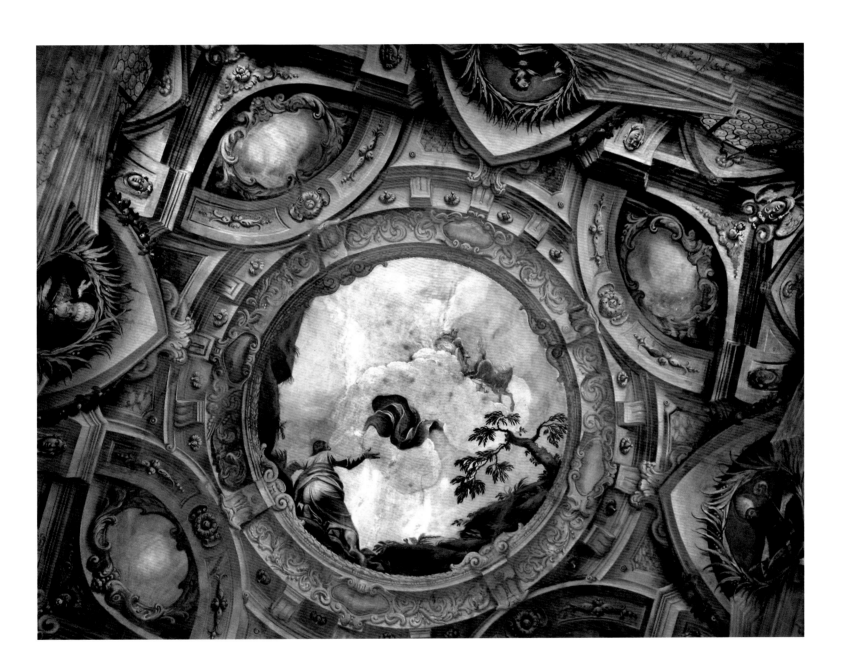

110 **Statue inside the Entrance** Giadino Giusti

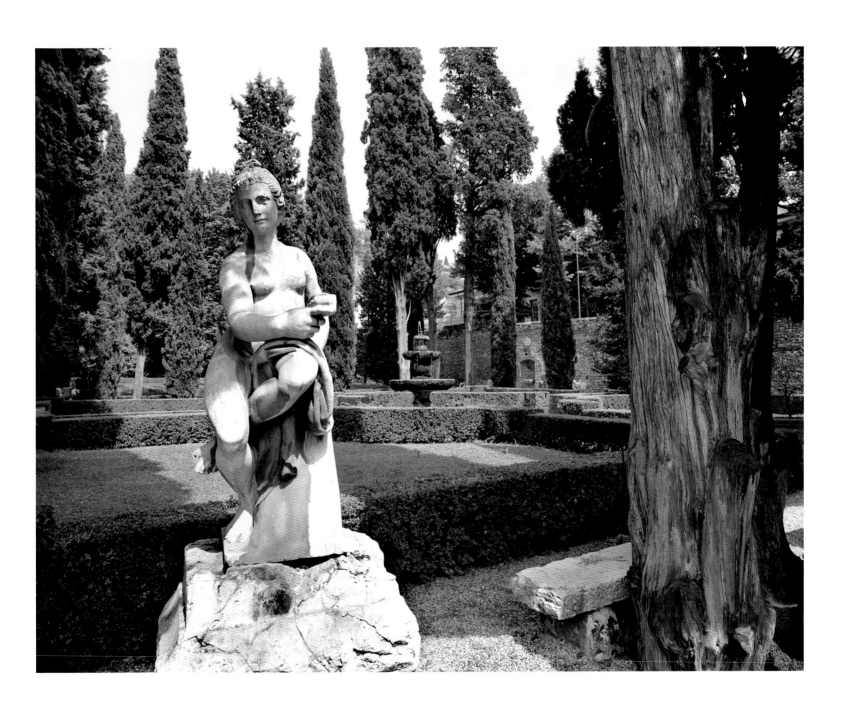

112 **Leaf Detail with Red Veins** Isola Bella

114 Statue Leading into Sunken Garden La Gamberaia

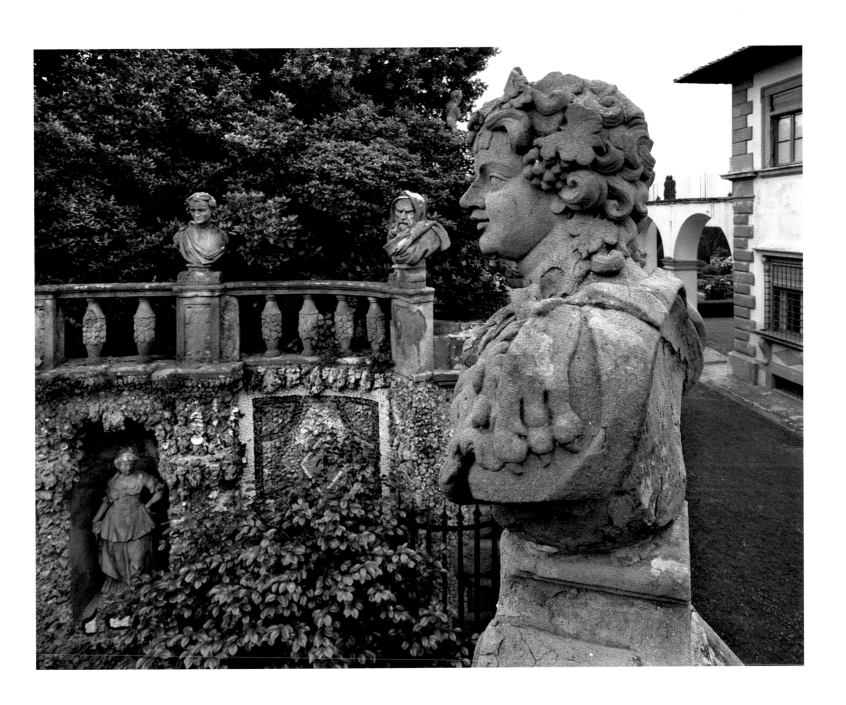

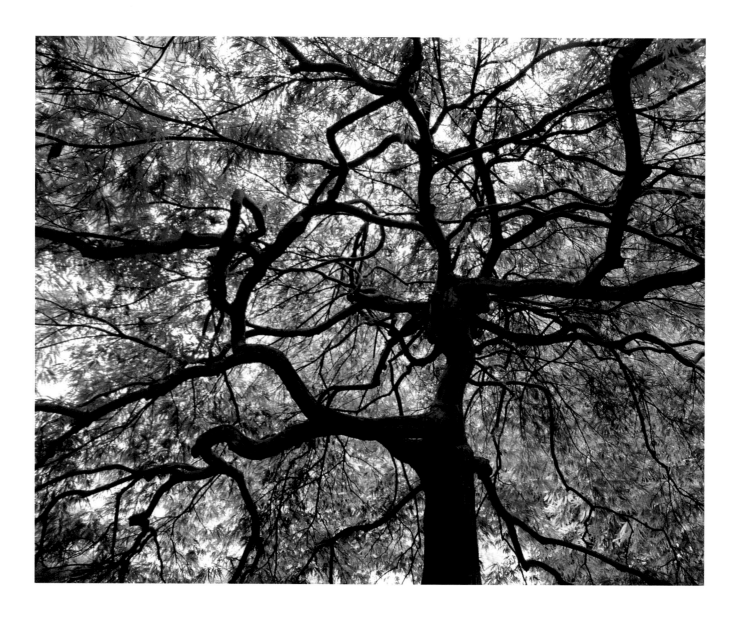

Tree Canopy Isola Madre

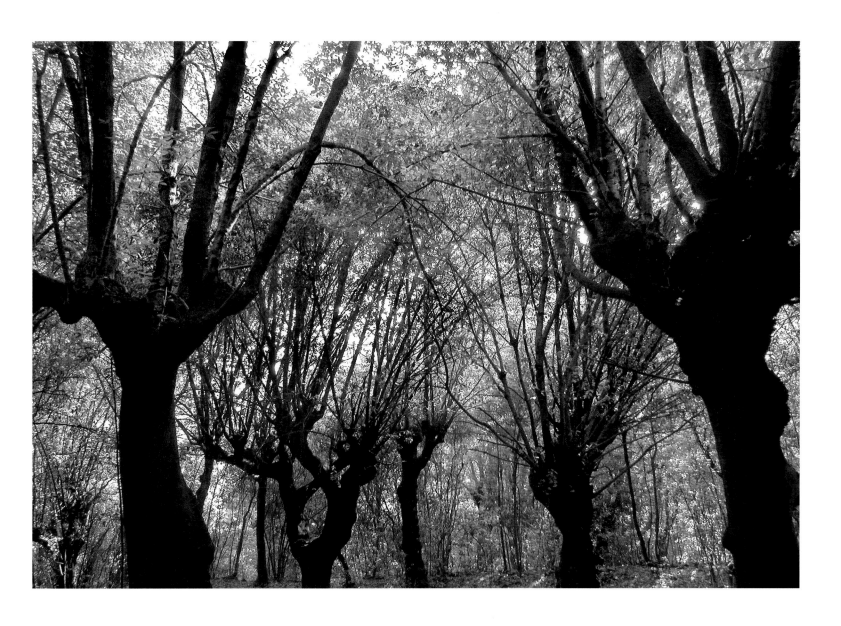

Sky Roots Boboli

118 Varigated Century Plant against the Water Isola Madre

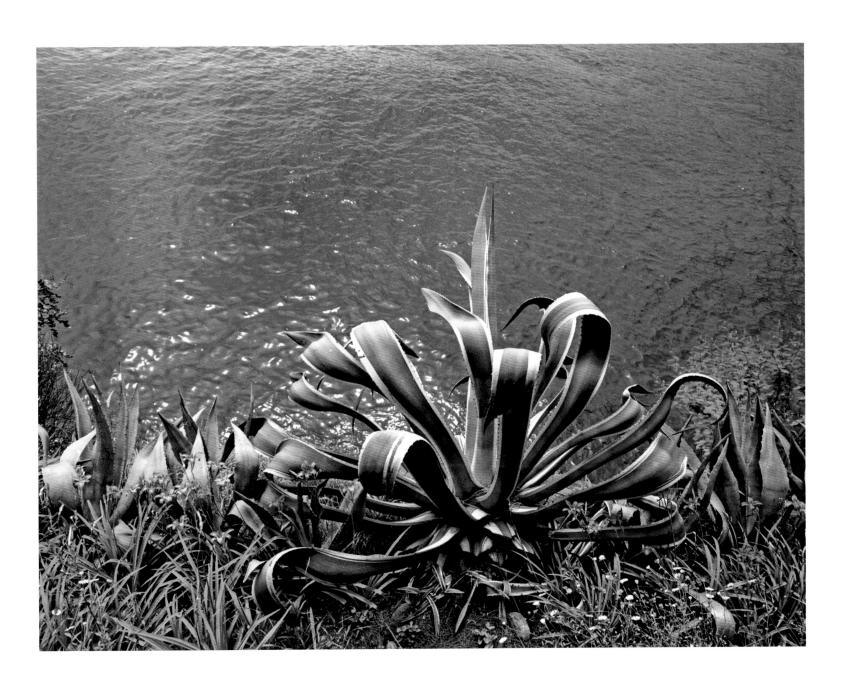

The Road Leaving the Villa Villa Arvedi

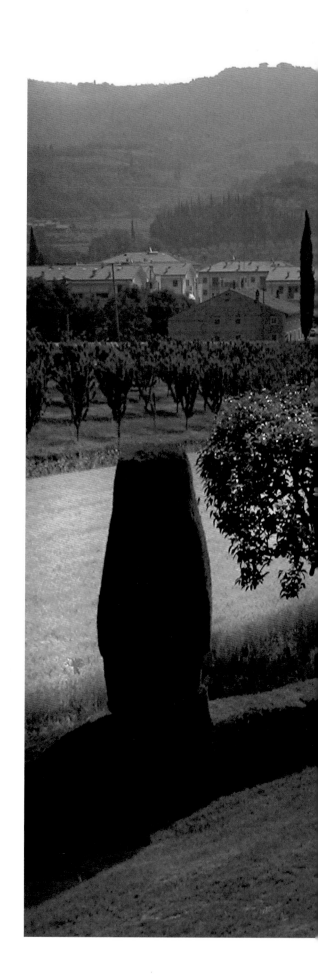

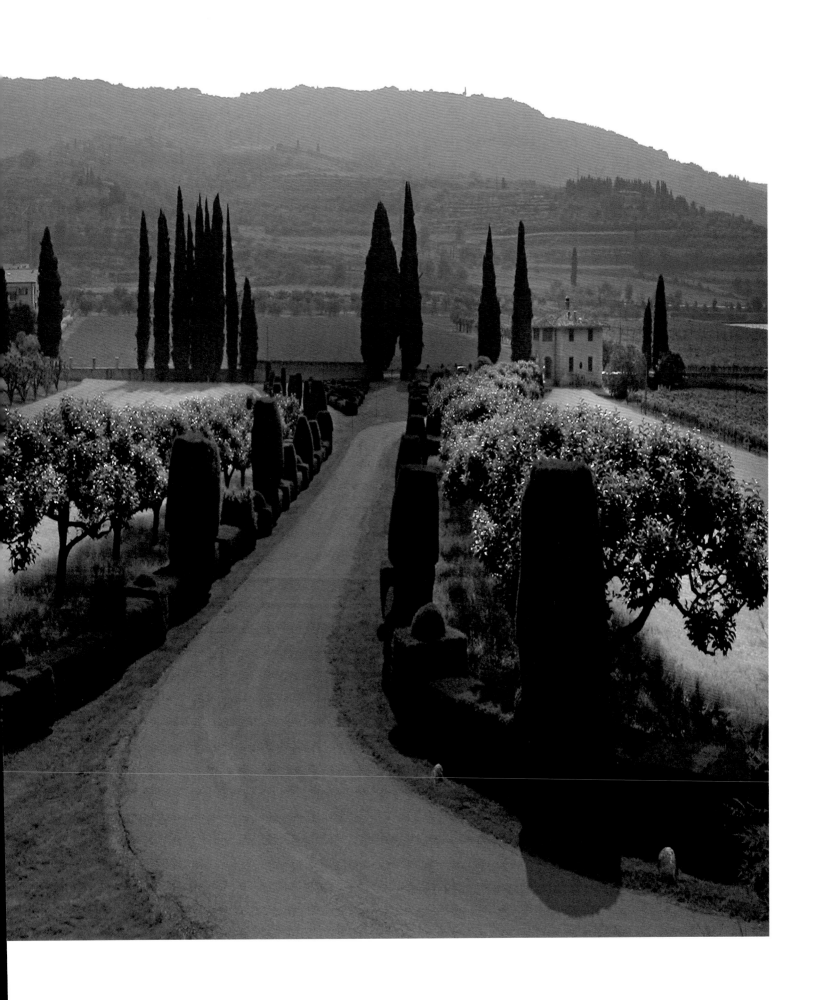

Villa Arvedi
Grezzana – Verona
Villa Arvedi, 37023 Grezzana (VR), Familie Arvedi
Tel. 045 – 90 70 45
Fax 045 – 90 87 66
E-Mail: arvedi@sis.it, www.villaarvedi.it
Öffnungszeiten: Führungen auf Anfrage

Die auf den steilen Abhängen eines Hügels ge-
legene, majestätische Villa Allegri, deren Ursprün-
ge bis ins 13. Jahrhundert zurückreichen, wurde
im 17. Jahrhundert von dem Architekten und Bild-
hauer G. B. Bianchi in ihrer heutigen Form errich-
tet. 1824 gelangte die Villa in den Besitz des Vero-
nesers Giovanni Antonio Arvedi.
Von dem Anwesen blickt man hinaus auf ein
Parterre, das sich harmonisch in die umgebende
Landschaft einfügt. Wahrhaft majestätisch ist die
Chaussee aus sorgfältig geschnittenen Buchs-
bäumen, die vom Eingang bis zur Villa führt. Die
elegante barocke Kapelle St. Carlo Borromeo
wurde Ende des 17. Jahrhunderts auf der Rück-
seite der Villa errichtet: Von dieser Kapelle aus,
quer durch den Haupt-Salon der Villa und den
Haupteingang hindurch, eröffnet sich eine zau-
berhafte Perspektive auf das Parterre und die
gegenüberliegenden Hügel.

Giardino Giusti
Verona
Via Giardino Giusti, 2 Verona
Tel. 045 – 380 29
Öffnungszeiten: täglich von 9–20 Uhr

Erschaffen am Ende des 15. Jahrhunderts zeigt
sich der Garten noch heute, wie er von Agostino
Giusti geplant wurde. Vom Herrenhaus führt eine
berühmte Zypressen-Chaussee hinauf zu einer
Höhle voller Stalaktiten, und vom Belvedere aus
eröffnet sich einer der schönsten Blicke auf
Verona.
Neben der Blumensammlung und bedeutenden
Ruinen aus der Römerzeit wurde auch die Ge-
staltung des 16. Jahrhunderts originalgetreu be-
wahrt: Springbrunnen, Echo-Höhlen, Pergolen, in
italienischer Manier geschnittene Buchsbäume,
Statuen mythologischer Gestalten sowie ein klei-
nes, aber komplexes Labyrinth, bekannt als eines
der ältesten in Europa. Besucht und gefeiert
durch die Jahrhunderte von berühmten Persön-
lichkeiten aus Geschichte und Kultur (darunter
Cosimo de Medici, Kaiser Joseph II., Goethe,
Mozart und Gabriel Fauré) bildet der Garten mit
dem angrenzenden Palast aus dem 16. Jahrhun-
dert ein faszinierendes Ensemble von klassischer
Schönheit.

Il Biviere
Lentini – Syrakus
Contrada il Biviere, 96016 Lentini (SR)
Maria Carla Borghese
Tel. 095 – 783 14 49
Fax 095 – 783 55 75
Öffnungszeiten: Führungen nach Vereinbarung
Eintritt: 6 € pro Person

Die Legende besagt, dass Herkules, der Sohn
Jupiters, an diesem Ort Ceres, der Göttin des
Ackerbaus, das Fell des besiegten Nemischen
Löwen darbot. Das Staatsarchiv von Palermo
bewahrt das Originaldokument des Edikts von
König Marino (1392) auf, welches besagt, dass
das Lehen, das „Il Biviere di Lentini" genannt wird,
einem Vorfahren mütterlicherseits der heutigen
Besitzerfamilie zugesprochen wird.
Dank des Enthusiasmus' der gegenwärtigen
Besitzer und ihrer Liebe zu Pflanzen wurde diesem
Stück Land noch einmal neues Leben einge-
haucht. Scipione und Maria Carla Borghese
verwandelten es auf eigene Faust in einen ein-
zigartigen mediterranen Garten. Üppige Palmen,
blaue Jacarandas, alte Rosensorten und eine
bemerkenswerte Sammlung von Kakteen und
Sukkulenten bezaubern den Besucher.

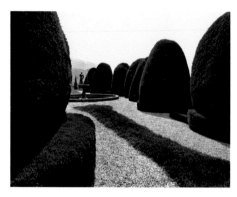 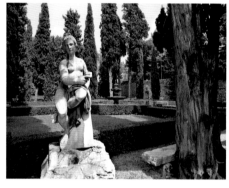 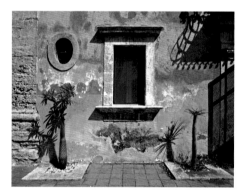

Villa Arvedi
Grezzana – Verona
Villa Arvedi, 37023 Grezzana (VR), Family Arvedi
Tel. 045 – 90 70 45
Fax 045 – 90 87 66
E-mail: arvedi@sis.it; www.villaarvedi.it
Opening times: Guided tours on request

Situated on the steep slopes of a hillside, the
majestic Villa Allegri, whose origins go back to
the 13th century, was constructed in its present
form by the architect and sculptor, G. B. Bianchi,
in the 17th century. The villa passed into the hands
of the 'gentleman of Verona', Giovanni Antonio
Arvedi, in 1824.
From the mansion itself, one looks out across a
lower terrace that blends harmoniously into the
surrounding landscape. The avenue of carefully
trimmed box-trees extending from the entrance
up to the villa is truly magnificent. The elegant
Chapel of St. Carolus Borromeus was added to the
rear of the house at the end of the 17th century:
from this chapel, one can enjoy an enchanting
view that leads the eye across the main salon of
the villa and through the main entrance to the
terrace and the hills opposite.

Giardino Giusti
Verona
Via Giardino Giusti, 2 Verona
Tel. 045 – 380 29
Opening hours: daily, 9 a.m. to 8 p.m.

Laid out at the end of the 15th century, the garden
as we see it today is still just as Agostino Giusti
planned it. A famous avenue of cypress trees
leads up from the manor house to a cave con-
taining many stalactites, while the belvedere
offers one of the loveliest views of Verona.
In addition to the collection of flowering plants
and important ruins from Roman times, the origi-
nal layout and ornamentation of the garden
have been carefully retained: fountains, echoing
grottoes, pergolas, box-trees trimmed in the Italian
style and statues of mythological figures, along
with a small but complex labyrinth, which is
famous for being one of the oldest of its kind in
Europe. Over the centuries, this garden has been
visited and praised by numerous illustrious figures
of historical and cultural importance (including
Cosimo de Medici, Emperor Joseph II., Goethe,
Mozart and Gabriel Fauré) and, with the neigh-
bouring 16th-century palace, comprises an
intriguing ensemble of classic beauty.

Il Biviere
Lentini – Syracuse
Contrada il Biviere, 96016 Lentini (SR),
Maria Carla Borghese
Tel. 095 – 783 14 49
Fax 095 – 783 55 75
Opening times: Guided tours by appointment
Entrance fee: 6 € per person

Legend has it that this is the site where Hercules,
the son of Jupiter, made an offering of the skin of
the Nemean Lion that he had killed for Ceres, the
goddess of agriculture. The city archives of
Palermo contain the original manuscript of an
edict of King Marino (1392), in which the fief
called "Il Biviere di Lentini" was granted to a
maternal ancestor of the present owner.
Thanks to the enthusiasm of the current owners
and their love of plants, this estate has been
given a new lease on life. On their own initiative,
Scipione and Maria Carla Borghese have trans-
formed it into a uniquely special Mediterranean
garden, so that the visitor is enchanted by its
luxuriant palm-trees, blue jacarandas, traditional
rose varieties and a remarkable collection of
cacti and succulents.

Isola Bella und Isola Madre
Verbania
Isola Bella (VB)
Öffnungszeiten: 24. März bis 20. Oktober
Information: Tel. 03 23 – 305 56, Fax 03 23 – 300 46
Isola Madre (VB)
Öffnungszeiten: 24. März bis 20. Oktober
Information: Tel. 03 23 – 312 61, Fax 03 23 – 300 45

1632 begann Graf Vitaliano Borromeo mit der Er-
richtung des monumentalen barocken Gebäudes
und der herrschaftlichen Gestaltung des Gartens
Isola Bella. Der Wohnsitz der Borromeos bietet im-
mer noch einen prächtigen Anblick und beher-
bergt unschätzbare Kunstwerke. Der Garten selbst
ist ein ungewöhnliches blumiges Baudenkmal, das
sich auf kunstvollen Terrassen entfaltet, ein klas-
sisches Beispiel der italienischen Gartenkunst im
17. Jahrhundert. Die spektakuläre Blütenpracht ist
sorgfältig geplant, damit der Betrachter von März
bis Oktober Farben und Düfte genießen kann.
Ein paar Minuten Bootsfahrt weiter entfernt liegt
die Isola Madre. Sie ist die größte der Borromä-
ischen Inseln und bekannt für ihre stille, verzau-
berte Atmosphäre: ein Garten voll seltener Pflan-
zen und exotischer Blumen, in dem Pfaue, Papa-
geien und Fasane frei umherstreifen. Die Isola
Madre ist berühmt für ihre Azaleen, ihre Rhodo-
dendren und Kamelien, doch ebenso für ihre
alten Glyzinien-Pergolen, die größte Kaschmir-Zy-
presse Europas sowie die Hibiskus-Sammlung.

Giardino di Villa Gamberaia – Zalum
Settignano – Florenz
Garten der Villa Gamberaia, Via del Rossellion 72,
Settignano (FI)
Öffnungszeiten (des Gartens): täglich von 9 Uhr
bis 19 Uhr (die Kasse schließt um 18 Uhr)
Die Villa kann nur nach Voranmeldung besichtigt
werden.
Tel. 055 – 69 72 05 oder 055 – 69 70 90
Fax 055 – 69 70 90, e-mail: villagam@tin.it
Eintritt: 10 € pro Person

Dieses relativ kleine Besitztum (etwa einen Hektar
groß) vereinigt die architektonische und land-
schaftsplanerische Weisheit und Erfahrung von
drei Jahrhunderten, vom 17. bis zum 20., und bie-
tet einen wirklich wunderbaren Blick, der sich vom
Hügel über Settignano erstreckt, von wo er sich
auf die Stadt Florenz und das Tal des Flusses Arno
weitet. Die Villa, errichtet auf dem bescheidenen
Geburtshaus des Bildhauers Rossellino, wurde
1610 vollendet. Die ursprünglichen Bewohner, die
Familie Lapi, verkaufte sie an das Geschlecht der
Capponis, welche den Garten vergrößerten und
Statuen und Springbrunnen hinzufügten. Anfang
des letzten Jahrhunderts wurde die Villa von der
ebenso schönen wie exzentrischen Russin Giovan-
na Ghyka erworben, die einen Teil ihres Lebens der
Umgestaltung des bereits berühmten Gartens
widmete, die vorhandenen immergrünen Pflan-
zen mit farbenprächtigen Rosen und Blumen
kombinierte und den Garten aus dem 18. Jahr-
hundert in eine Anlage im italienischen Stil ver-
wandelte.

Giardini della Landriana
Tor San Lorenzo – Ardea – Rom
Giardini della Landriana, Via Campo di Carne
00040 Tor S. Lorenzo, Ardea (Rom)
Eredi Lavinia taverna
Tel. 06 – 91 01 41 40, Fax 06 – 687 28 39
Öffnungszeiten: jedes Wochenende von April bis
Oktober, 10–12 Uhr und 15–18 Uhr
(16–19 Uhr im Juli und August)
Anmeldung von Reisegruppen für jeden
Wochentag möglich.

Auf einer Größe von zehn Hektar im Küstengebiet
von Ardea, 40 Kilometer südlich von Rom gele-
gen, halten die Gärten der Landriana viele ange-
nehme Überraschungen bereit. Die erstmals von
Russell Page angelegten Gärten wurden im Laufe
der Jahre immer wieder erweitert und verändert;
zahlreiche Pflanzen, wie Heidekraut, Hortensien,
alte Rosensorten und Kamelien, wurden einge-
führt. Ein bedeutendes Charakteristikum der
Gärten ist ihre Aufteilung in 30 „Zimmer", darunter
insbesondere erwähnenswert der Rosengarten,
in dem unzählige, zart duftende Rosen in Beeten
wachsen, die mit Lavendel, Thymian und Garten-
nelken eingefasst sind; der Orangengarten, einer
der „formalen Gärten" von Landriana; der Oliven-
garten; die weiße Chaussee, eine lange Treppe,
flankiert von großen weißen Blumenbeeten; der
blaue Rasenplatz mit seinen vor allem blauen
Pflanzen; der spanische Teich, verborgen zwischen
Kampferbäumen.

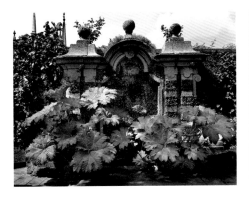

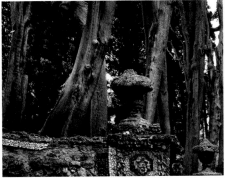

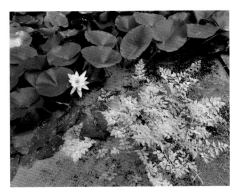

Isola Bella and Isola Madre
Verbania
Isola Bella (VB)
Open from 24th March to 20th October
Tel. 03 23 – 305 56; Fax 03 23 – 300 46
Isola Madre (VB)
Open from 24th March to 20th October
Tel. 03 23 – 312 61; Fax 03 23 – 300 45

In 1632, Count Vitaliano Borromeo initiated work
on the construction of this monumental Baroque
building along with the grandiose formal garden,
Isola Bella. The residence of the Borromeos is still a
magnificent sight and houses many invaluable
works of art. The garden itself is an unusually ornate
architectural monument extending over delightful
terraces, the whole comprising a classic example
of 17th-century Italian horticultural art. The spec-
tacular ranges of flowering plants have been
chosen with care, so that the visitor can enjoy
their colours and fragrances from March until
October.
Just a short boat-ride away, the Isola Madre is the
largest of the Borromeo Islands and is renowned
for its tranquil and enchanting atmosphere: a
garden brimming over with rare plants and exotic
flowers, where peacocks, parrots and pheasants
live in the wild. The Isola Madre is particularly well-
known for its azaleas, rhododendrons and camel-
lias, as well as for its wisteria pergolas, Europe's
largest specimen of Cashmir cypress and its
collection of hibiscus plants.

Giardino di Villa Gamberaia – Zalum
Settignano – Florence
Garden of the Villa Gamberaia,
Via del Rossellion 72, Settignano (FI)
Opening hours (of the garden):
daily, 9 a.m. to 7 p.m. (last entry at 6 p.m.)
The villa may only be viewed by prior appointment
Tel. 055 – 69 72 05 or 055 – 69 70 90
Fax 055 – 69 70 90
E-mail: villagam@tin.it
Entrance fee: 10 € per person

This relatively small estate (with an area of about
2.5 acres) embodies and combines no less than
three centuries (17th to 20th centuries) of architec-
tural and landscaping wisdom and experience; it
also offers a truly marvellous view extending from
the hill above Settignano towards the city of
Florence and the valley of the River Arno.
The villa was completed in 1610, being erected on
the site of the modest house where the sculptor,
Rossellino, was born. The original residents, the Lapi
Family, sold it to the Capponis, who enlarged the
garden, adding fountains and statues. At the
beginning of the last century, the villa was bought
by Giovanna Ghyka, a Russian woman as beauti-
ful as she was eccentric, who devoted a period of
her life to redesigning this garden that already
enjoyed great renown. She combined the rather
austere evergreen plants already there with
colourful roses and other flowers, and transformed
the 18th-century garden into an Italian-style park.

Giardini della Landriana
Tor San Lorenzo – Ardea – Rome
Giardini della Landriana, Via Campo di Carne,
00040 Tor S. Lorenzo, Ardea (Rome), Eredi Lavinia
taverna
Tel. 06 – 91 01 41 40; Fax 06 – 687 28 39
Opening hours: April to October, weekends from
10 to12 a.m. and 3 to 6 p.m.
(July and August, 4 to 7 p.m.)
Groups by appointment on weekdays

Located in the coastal region of Ardea (25 miles
south of Rome) and with an area of about 25
acres, the Landriana Gardens have a number of
delightful surprises in store for visitors. Initially laid
out by Russell Page, these gardens have under-
gone continual enlargement and alteration, with
numerous types of plants, such as heathers, hy-
drangeas, traditional rose varieties and camellias
being added over the years. A particularly char-
acteristic feature of this garden is its division into
30 'rooms', of which the most remarkable include
the rose garden, in which countless roses of deli-
cate fragrances are planted in beds with borders
of lavender, thyme and clove pinks; the orange
garden, one of Landriana's 'formal' gardens; the
olive garden; the white avenue, a long staircase
flanked by large beds of white flowers; the 'blue
field', where most of the plants have blue flowers;
and the Spanish pond hidden amid camphor
trees.

La Mortella
Forio - Insel Ischia - Neapel

La Mortella, Via F. Calise 39, 80075 Forio,
Insel Ischia (NA)
Lady Susana Walton,
Tel. 081 - 98 62 20
Fax 081 - 98 62 37
e-mail: mortella@pointel.it, www.ischia.it/mortella
Öffnungszeiten: jeden Dienstag, Donnerstag,
Samstag und Sonntag von April bis Mitte
November

In der Umgebung von Zaro, eine der malerisch-
sten Ecken der Insel Ischia, liegt „La Mortella", der
prächtige Garten, entworfen von Susana, der
Gattin von William Walton, einem der wichtigsten
britischen Komponisten des 20. Jahrhunderts.
1956 plante der bedeutende Landschaftsarchi-
tekt Russell Page die Gartenanlage auf den vor-
handenen felsigen Lavaformationen. Die vertika-
len Terrassen des Gartens - direkt in den Fels ge-
hauen - beherbergen eine Sammlung von über
800 seltenen exotischen Pflanzenarten, wie etwa
Farn von den Kanarischen Inseln; Zwergrosmarin
aus Israel; den Puderquastenstrauch aus dem tro-
pischen Amerika; den Afrikanischen Tulpenbaum
aus dem tropischen Afrika und eine Gruppe von
nur in Australien heimischen Baumfarnen. Bei
einem Besuch des „Viktoria-Haus", ein tropisches
Gewächshaus, kann man Victoria amazonica
bewundern, die unumstrittene Königin der See-
rosengewächse.

Villa Reale di Marlia
Marlia - Lucca

Garten der Villa Reale, 55014 Marlia, Lucca
Tel./Fax 05 83 - 301 08/ 05 83 - 300 09
e-mail: villareale@cln.it
Öffnungszeiten: 1. März bis 30. November, in den
anderen Monaten nach Absprache. Führungen.
Montags geschlossen.

Einer der bedeutenden Schauplätze der Toskana,
die königliche Villa in Marlia, war seit langer Zeit
der Wohnsitz angesehener Familien und Förderer
der Künste. Napoleons Schwester, Elisa Baciocchi,
Gebieterin über Lucca und später über die Tos-
kana, schuf dieses grandiose Ensemble, indem sie
die ausgedehnten Anlagen der Villa Orsetti mit
der ehemaligen Sommerresidenz der Bischöfe
von Lucca vereinigte. Sie modernisierte den alten
Orsetti-Palast im zeitgenössischen Empire-Stil, die
herrlichen Orsetti-Gärten aus dem 17. Jahrhun-
dert aber, einschließlich des grünen Freiluft-
Theaters, wurden im Wesentlichen so belassen,
wie sie waren.
Nach dem Sturz Napoleons und im Zuge der
Vereinigung Italiens gelangte die Villa in den
Besitz von Viktor Emanuel II., welcher sie Prinz
Carlo übertrug, dem Bruder des letzten Königs
der „beiden Sizilien". Im Jahr 1923 erwarben Graf
und Gräfin Pecci-Blunt, die Eltern des heutigen
Besitzers, das Anwesen.

Giardino Barbarigo Pizzoni Ardemani
Valsanzibio di Galzignano

Giardino Barbarigo Pizzoni Ardemani
Via Barbarigo, Valsanzibio di Galzignano (PD)
Tel. 049 - 805 56 14
Fax 049 - 913 00 29
Öffnungszeiten: von März bis November
täglich von 9 - 12 Uhr und von 14 Uhr bis
Sonnenuntergang

Valsanzibio, einer der wichtigsten und ältesten
Gärten Europas, wurde Mitte des 17. Jahrhunderts
von dem venezianischen Aristokraten Zuane Fran-
cesco Barbarigo im großen Stil umgestaltet. In
jüngerer Zeit gelangte das Anwesen in den Besitz
des Adeligen Fabio Pizzoni Ardemani und wurde
von ihm wiederhergestellt.
Wasser in Hülle und Fülle belebt nun die außerge-
wöhnliche Welt der Springbrunnen, Wasserfälle,
Wasserspiele, Fischteiche und Bäche. Die schönen,
von Merengo geschaffenen Statuen verleihen
Gartenabschnitten oder Durchblicken, einge-
rahmt von Mauern oder alten Bäumen, deren
verschiedene Grüntöne von weißen Blumen
durchsetzt werden, einen tieferen Sinn. Darüber
hinaus beheimatet der lesbare symbolische -
Garten Valsanzibio einen Irrgarten, eine Kanin-
cheninsel sowie einen vollständig funktionieren-
den Wassergarten.

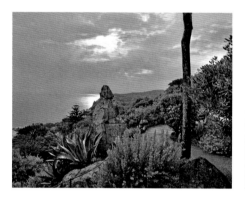

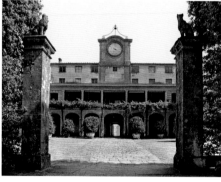

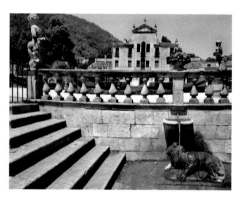

La Mortella
Forio - Island of Ischia - Naples

La Mortella, Via F. Calise 39, 80075 Forio,
Isola Ischia (NA), Lady Susana Walton
Tel. 081 - 98 62 20
Fax 081 - 98 62 37
E-mail: mortella@pointel.it; www.ischia.it/mortella
Open from April to mid-November on Tuesdays,
Thursdays, Saturdays and Sundays

Located in the vicinity of Zaro, one of the most
picturesque corners of the island of Ischia, 'La
Mortella' is a splendid garden designed by Susana
Walton, the wife of Sir William Walton, one of the
most important British composers of the 20th cen-
tury. In 1956, the famous landscape gardener,
Russell Page, drew up plans for this garden incor-
porating the rocky lava formations characterising
the site. The vertical terraces of the gardens - cut
directly into the rocky terrain - are the home of
over 800 rare varieties of exotic plants, these in-
cluding unusual ferns from the Canary Islands,
dwarf rosemary from Israel, the powder-puff bush
from the tropical regions of America, the African
tulip-tree from tropical Africa and a group of tree
fern varieties only found in Australia. In the large
greenhouse devoted to tropical plants, one can
admire specimens of Victoria amazonica, the
undisputed queen of the waterlilies.

Villa Reale di Marlia
Marlia - Lucca

Garden of the Villa Reale, 55014 Marlia, Lucca
Tel. 0583 - 301 08; Fax 05 83 - 300 09
E-mail: villareale@cln.it
Open from 1st March to 30th November, daily
except Mondays; otherwise by appointment
only (guided tours available)

One of the most important historical sites in
Tuscany, the royal villa in Marlia long served as the
residence of illustrious families and patrons of the
arts. It was Napoleon I's sister, Elisa Baciocchi -
ruler of Lucca and later of Tuscany - who created
this magnificent ensemble by uniting the extensive
grounds of the Villa Orsetti with the former summer
residence of the bishops of Lucca. She modernised
the old Orsetti Palace in the prevailing Empire
style, while leaving the lovely 17th-century Orsetti
Gardens (including a grassed open-air theatre)
essentially untouched.
After the fall of Napoleon and during the course
of the Unification of Italy, this villa passed into the
possession of Victor Emanuel II, who then gave it
to Prince Charles, the brother of the last king of
the "Two Sicilies". In 1923, the estate was pur-
chased by Count and Countess Pecci-Blunt, the
parents of the present owner.

Giardino Barbarigo Pizzoni Ardemani
Valsanzibio di Galzignano

Giardino Barbarigo Pizzoni Ardemani,
Via Barbarigo, Valsanzibio di Galzignano (PD)
Tel. 049 - 805 56 14
Fax 049 - 913 00 29
Opening hours: March to November, daily from
9 to 12 a.m. and from 2 p.m. until sunset

One of the oldest and most important gardens in
Europe, Valsanzibio was redesigned on a grand
scale in the mid-17th century by the Venetian aris-
tocrat, Zuane Francesco Barbarigo. In more recent
times, the estate passed into the hands of the
nobleman, Fabio Pizzoni Ardemani, who subjected
it to a thorough restoration.
Water is a predominant element in this remark-
able world of fountains, waterfalls, fish-ponds and
streams. Framed by walls or ancient trees, whose
endless nuances of green are flecked by white
flowers, the delightful statues by Merengo infuse
the various sections and vistas of the garden
with a deeper meaning. Containing, in addition,
a maze, a 'rabbit-island' as well as a fully func-
tional water-garden, the Valsanzibio Garden is
characterised by an underlying and coherent
symbolism.

Giardino di Boboli - Florenz
Giardino di Boboli, Piazza Pitti, Florenz
Tel. 055 - 21 87 41
Öffnungszeiten: von November bis Ende Februar
täglich 9 - 15.30 Uhr, von März bis Mai und
Sept./Okt. täglich 9 - 17.30 Uhr, von Juni bis Ende
August täglich 9 - 18.30 Uhr; jeden ersten und
letzter Montag im Monat Ruhetag
Eintritt: 2 €

Der Giardino di Boboli, hinter dem Palazzo Pitti,
dem Hauptsitz der Medici, gelegen, ist einer der
bekanntesten italienischen Gärten des 16. Jahr-
hunderts. Angelegt wurde der Garten mit seinen
langen Achsen, den breiten Kieswegen, den
Grotten und den zahlreichen Statuen und Brun-
nen ganz im Stil der Zeit ab 1549 von Eleonora von
Toledo I., der Ehefrau von Großherzog Cosimo I.
Die Hauptachse ist auf die rückwärtige Fassade
des Palazzos gerichtet und steigt vom Amphi-
theater, in dessen Mitte sich ein ägyptischer Obe-
lisk befindet, den Boboli-Hügel hinauf. In mehre-
ren Phasen von berühmten Gartenarchitekten
und Künstlern erweitert und ausgebaut erhielt der
Garten im 17. Jahrhundert seine heutige Größe
von 4,5 Hektar; trotz seiner langen Geschichte
konnten im Boboli-Garten die meisten originalen
Elemente aus Renaissance und Barock bewahrt
werden.

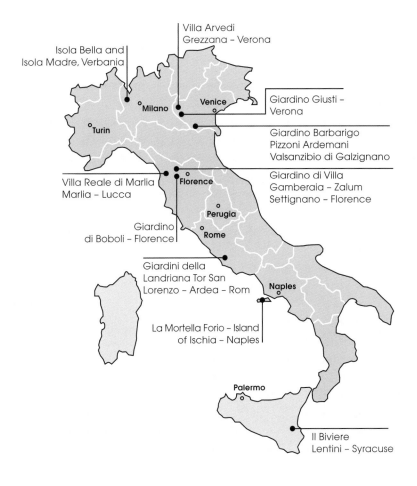

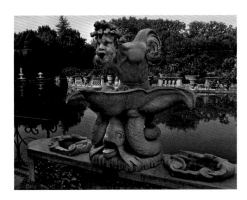

Giardino di Boboli
Florence
Giardino di Boboli, Piazza Pitti, Florence
Tel. 055 - 21 87 41
Opening hours: November to the end of
February, daily 9 a.m. to 3.30 p.m.; March to
May and September/October, daily 9 a.m. to
5.30 p.m.; June to the end of August,
daily 9 a.m. to 6.30 p.m. (closed on the first and
last Monday of each month)
Entrance fee: 2.00 €

The Boboli Garden located behind the Palazzo
Pitti, the principal residence of the Medicis, is one
of the best-known Italian gardens dating from
the 16th century. Its long axes, broad gravel paths,
grottoes and numerous statues and fountains are
characteristic of the period when it was laid out
(from 1549 on) by Eleonora of Toledo I, the wife of
Grand Duke Cosimo I. The principal axis points
towards the rear façade of the palazzo, rising up
the Boboli Hill from an amphitheatre, at the centre
of which stands an Egyptian obelisk. Extended and
enlarged over several phases by famous garden
architects and artists, the garden attained its
present size of just over 11 acres during the 17th
century. In spite of its long history, the Boboli Gar-
den has managed to retain most of its original
Renaissance and Baroque features.

n einer gut zweiwöchigen Reise durch zwölf großartige Italienische Gärten hat Douglas I. Busch fotografische Eindrücke gesammelt. Vom Fuß der Alpen bis nach Sizilien hat er das Land, seine geografische Struktur und seine verschiedenen Klimazonen durchmessen. Herausgekommen – und dies macht Buch wie Ausstellung so charmant – ist der sensible Blick des Künstlers auf vielgeliebte halböffentliche Räume, denn angelegt waren die Gärten ursprünglich nicht für die Allgemeinheit. Dass sie dies heute sind, ist ebenso ein Segen wie die Vielfalt ihrer Geschichte und Geschichten. In den Fotografien Douglas Buschs sind Gegenwart und Historie gleichermaßen spürbar, in der Komposition der Anlagen wie der Bilder, in Alter oder Jugend der Pflanzen. Die Privatheit der Gärten – denn immer finden wir in ihnen Momente, in denen sie nur uns, den Besuchern gehören – trifft auf die Intimität der Bilder, die den Geist der Anlagen auch in der Begrenztheit des Bildausschnittes spürbar machen.

Dieser magische Augenblick macht aus Bildern Kunst und zeigt uns zugleich die Kunst der Gartenanlage: das virtuose Spiel mit Masse und Raum in Kompositionen aus Pflanzen, Gebäuden, geografischen Strukturen und den Zeiten.

Der Zauber von Jahrhunderten liegt über den großen Gärten Italiens, die einst von klugen Geschlechtern errichtet wurden. Ihre Inspirationsquellen waren die Schöpfungen der Alten, die schon vor Alexanders Eroberungszügen in ihren Gärten Orient und Okzident zu luxuriösen Geschöpfen zusammengeführt hatten. Hinter den Toren der Gärten pflegte man die gebildete Muße und konnte sich für eine Weile der Vorstellung hingeben, die Zeit in der Zeit festzuhalten. Die Sinnenfräulein aus Francesco Colonnas Hypnerotomachia Poliphili knüpfen in italienischen Gärten ein untrennbares Zusammenspiel. Unter dem Himmel einer glücklichen geographischen Lage bilden Stützmauern, Rampen, Terrassen und Treppen das architektonische Gerüst. Hecken säumen Wege, meisterliche ars topiaria unterstreicht mit ihren Figuren die Achsen vorgegebener Strukturen oder betont bildwichtige Punkte der Gartenreiche. Pergolen aus Holz oder Stein sind überfangen mit reichem Blüten- und Blattwerk, das lichtdurchspielte Schatten spendet. Pflanzgefäße zieren Balustraden, steinerne Figuren erzählen aus den Mythen der Antike. Von hoher Ingenieurskunst in Rinnen, Becken und Brunnen gelenkte und in die Höhe getriebene Wasser bilden das alles belebende Element. Behutsam nähert sich Douglas Busch diesen Orten mit ihren Blicken hinaus in geschichtsgesättigte Landschaften und in ihre verborgenen, von Pflanzen und altem Mauerwerk beschützten Winkel, in denen das ungerührte Plätschern alter Brunnen die Stille unterstreicht. Die in gerader Linie gelenkten Höhenzüge der Wege, die zu vielen Villen führen, hat Douglas Busch in seinen Arbeiten so festgehalten, dass sie gleich einem Sog in die grünen Reiche ziehen, zugleich aber auch das menschliche Maß der Anlagen deutlich werden lassen. Nie negiert die Kamera die großzügige Intimität der Räume italienischer Gärten, die so charakteristisch für die Paradiese dieses Landes sind. Und nie verschweigt die Kamera die noble Patina dieser Gärten, die bis heute vorbildhaft sind für die Gestaltung von Räumen unter freiem Himmel.

Gabriele Uerscheln und Thomas Schirmböck

During a trip lasting just over two weeks in which he visited 12 magnificent Italian gardens, Douglas I. Busch collected a wealth of photographic impressions. From the foothills of the Alps to Sicily, he traversed the whole peninsula, its geographic structures and its various climatic zones. The outcome – and this is what gives both the book and the exhibition their charm – is an artist's very sensitive account and view of these much-loved semi-public spaces – because these gardens were not originally laid out for the benefit of the general public. The fact that they are today openly accessible is just as much a blessing as the diversity of their history and the stories behind them. In the photographs of Douglas Busch, past and present are visible and perceptible to the same degree, in the layout and contents of the gardens as well as in the images themselves, in the ancientness or comparative youth of the plants that they house. The privacy of these gardens – because there are always those moments in them when they belong to us, the visitors, alone – corresponds to the intimacy of the pictures that tangibly capture the spirit of these gardens even when the composition is tightly cropped and focussed.

Such magical moments turn pictures into art and, at the same time, reveal to us the artistry of the gardens themselves: the virtuoso play with masses, forms and space within compositions of plants, buildings, geographic structures and times.

The enchantment of centuries extends over the great gardens of Italy, which were first laid out by shrewd and hard-headed families of noblemen. Their sources of inspiration were those creations of ancient civilizations that, even before the victorious campaigns of Alexander the Great, produced sumptuous horticultural wonders in both the Orient and Occident. Behind the gates of gardens, one pursued the art of learned leisure and could devote oneself for a time to the idea of bringing time to a standstill within the flow of time. A crucial feature of Italian gardens is the interplay of sensual young women derived from Francesco Colonna's Hypnerotomachia Poliphili. Under the skies of delightful geographical settings, walls, ramps, terraces and stairways comprise the architectural scaffolding and structure. Hedges skirt the pathways, figures that are masterpieces of the topiarist's art underline the axes of predetermined structures or emphasize visually important points within the garden. Pergolas made of wood or stone are covered with abundant flowering plants or foliage offering shade pierced by flecks of light. Pots and other vessels containing plants decorate balustrades, while stone figures recall myths from ancient times. Directed by refined engineering skills into channels, pools and fountains and spouting up into the air, water is the element that adds a dash of life to everything. It was with the utmost care and sensitivity that Douglas Busch approached these places with their views extending away into landscapes steeped in history as well as into secluded corners concealed and protected by plants and ancient walls, whose tranquillity may be underpinned by the gentle splashing of an old fountain. In his work, Douglas Busch has captured those precisely drafted straight paths that rise up towards many villas and mansions in such a way that they seem to draw us into a realm of foliage and greenery while, at the same time, revealing the human dimensions of these horticultural masterpieces. His camera never loses sight of the generous intimacy of Italian gardens that are such a characteristic feature of the paradisic nature of this country. And his camera never ignores the fine patina acquired over the centuries by these gardens, which continue to be prime examples of the art of spatial design under an open sky.

Gabriele Uerscheln and Thomas Schirmböck

DANKSAGUNG

Ein Prozess bedeutet Zusammenarbeit und die Zusammarbeit ist das Buch.

Dieses Buch ist eine künstlerische Zusammenarbeit im wahrsten Sinn des Wortes. Ohne die selbstlose Unterstützung von Freunden und Kollegen gleichermaßen wäre dieses Buch niemals möglich gewesen. Jeder Prozess ist, in einer verzwickten und komplexen Kombination aus Geben und Nehmen, abhängig von anderen.

An erster Stelle möchte ich Linda Wade, der dieses Buch gewidmet ist, dafür danken, dass sie von Beginn des Projektes an aktiv daran teilgenommen hat. Ihre Ermutigung und ihr hochgeschätzter Beistand haben in der Tat den Stil dieses Buches bestimmt. Meine Verpflichtung ihr gegenüber wird niemals weniger werden.

Dank auch an Thomas Schirmböck, der nicht aufhört, mich mit seiner standhaften Unterstützung als Kurator und Freund in Erstaunen zu versetzen. Unentwegt half er mir und leitete die Aufbereitung und Beschaffung von Ausstellungen für dieses Projekt; sein Einsatz für die Kunst der Fotografie war grenzenlos.

Besonders danken möchte ich Gabriele Uerscheln für ihr Vertrauen und ihre Unterstützung der Eröffnungsausstellung, Prinzessin Maria Carla Borghese für ihre Einführung und ihre freundlichen Worte, Günter Braus ist für die exzellenten Reproduktionen in seinem Buch zu loben und für seinen unermüdlichen Einsatz für die Kunst des Druckens und Publizierens, Dr. Donald Bartlett Doe für die jahrelange Unterstützung und Freundschaft und Al Weber hat über all die Jahre bereitwillig Informationen mit mir geteilt und eine wichtige Rolle in meiner fotografischen Ausbildung und Entwicklung als Künstler und Mensch gespielt.

Meiner Frau und besten Freundin, Lori Bruce Busch, möchte ich für ihren fortwährenden Beistand, ihr Verständnis und ihre Ermutigung in schwierigen Phasen dieses Projekts danken.

Zuletzt möchte ich auch den Gartenbesitzern danken. Ohne ihre Liebe und Hingabe an ihre Gärten gäbe es dieses Buch nicht.

Alle in diesem Buch vorgestellten Gärten gehören zur Gruppe Grandi Giardini Italiani.

ACKNOWLEDGEMENTS

The Process is the Collaboration and the Collaboration is the Book.

This book is an artistic collaboration in the truest sense of the word. Without the generous support of friends and colleagues alike this book would not have been possible. The process is dependent on others in an intricate and complex combination of give and take.

Foremost, I would like to thank Linda Wade—to whom this book is dedicated—for taking an active position from the beginning of this project. The encouragement and valued support truly set the tone for this book. My indebtedness will never diminish.

Thanks to Thomas Schirmböck, who continues to amaze me with his unwavering support as a curator and friend. His help and direction in editing and securing shows for this project has been steadfast and his commitment to the art of photography boundless.

Special thanks to Gabriele Uerscheln for her trust and support in the opening exhibition, The Princess Maria Carla Borghese for her introduction and kind words, Günter Braus is to be commended for the excellent reproductions in this book and his continuing commitment to the art of printing and publishing, Dr. Donald Bartlett Doe for all the years of support and friendship, and Al Weber—who over the years—has willingly shared information and played a major part of my photographic education and development as an artist and human being.

To my wife and best friend, Lori Bruce Busch, for her continuing support, understanding, and encouragement through the difficult periods of this project.

Finally, I wish to thank the garden owners. Without their love and devotion to their gardens this book would not have been possible.

All the gardens featured in this book are part of the Grandi Giardini Italiani group.

Impressum

Copyright
© Edition Braus
im Wachter Verlag GmbH
Heidelberg 2006

Für die Fotografien:
Douglas I. Busch

Für die Texte:
die Autoren

Übersetzungen:
Andrew Cowin,
Sabine Bayerl

Herausgeber:
Thomas Schirmböck

Layout:
Sylvia Wähler,
komplus GmbH, Heidelberg

Gesamtherstellung:
Wachter GmbH, Bönnigheim

ISBN 3-89904-218-2

www.editionbraus.de

128